one million manga characters

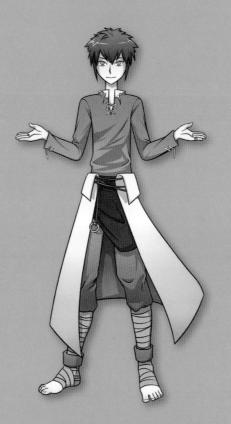

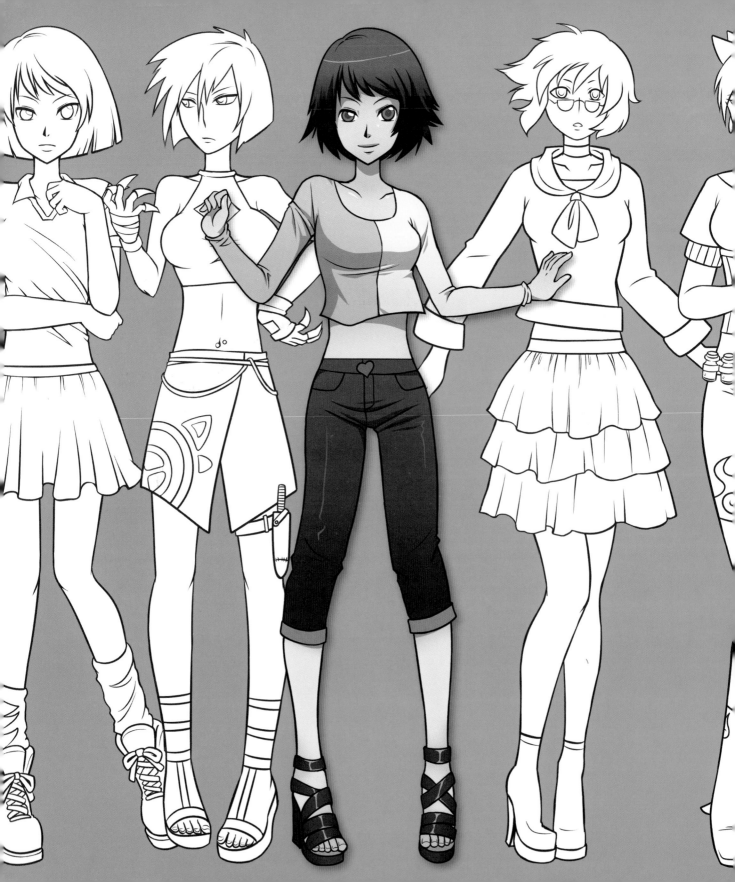

one million manga characters

over one million characters to create and color!

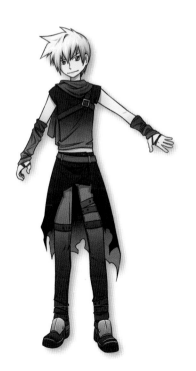

yishan li

with yishan studio and andrew james

Andrews McMeel
Publishing, LLC

Kansas City · Sydney · London

This book was conceived, designed,
and produced by
THE ILEX PRESS LIMITED
210, High Street, Lewes, BN7 2NS, UK

ILEX Editorial, Lewes:
Publisher: Alastair Campbell
Creative Director: Peter Bridgewater
Managing Editor: Nick Jones
Editor: Ellie Wilson
Art Director: Julie Weir
Designer: Richard Peters

Manufactured in China
First American Edition

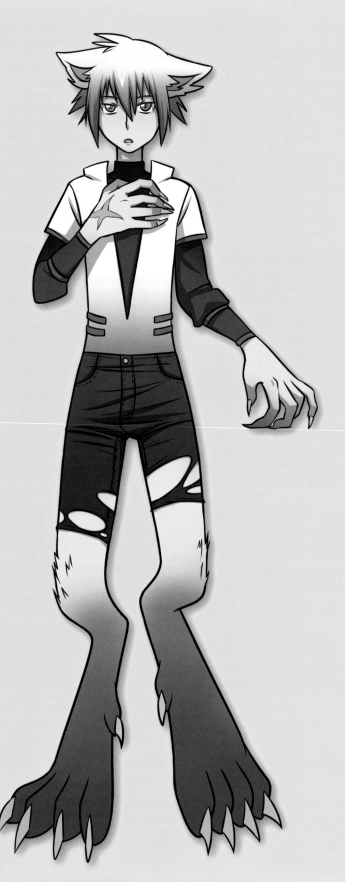

the contents

INTRODUCTION

Manga's roots stretch back to the nineteenth century, but there's absolutely nothing antiquated about this most thrilling modern art form. From shonen (boy's) action and shoujo (girl's) romance to adult manga's android philosophy, psychic serial killers, and workplace dramas, few forms of storytelling have devoted themselves so breathlessly to the entirety of human experience.

Here in the West, manga has been growing in popularity for more than a decade now, regularly topping best-seller lists, and is probably consumed by more voracious readers than the majority of any homegrown comics!

A large part of manga's popularity comes from the fact that, whatever you love to do, there is a manga for you. From romance to robot rampages, mah jong to martial arts, school dramas to science fiction, magic to mecha and all kinds of strange combinations in between, manga delights in pushing the limits of the form.

Manga is more than just its incomparable range of stories, however: its popularity also comes from the innumerable, memorable characters that populate its pages. Large-eyed with fantastic hair, these heroes and heroines are dynamic and instantly iconic. Now you can add your creations to this ever-growing list!

It was in the carved-woodblock school of printing that manga was born. Back then, the unofficial founding father of manga (and the first to use the term to describe his efforts), Hokusai, brought life to everyday scenes that were transferred to paper and shopped round the provinces in a printing process known as ukiyo-e.

Although Hokusai began the process, and many other artists began to produce strip cartoons around the turn of the twentieth century, it was thanks to another man, Osamu Tezuka, that manga began to achieve its full potential. Influenced by Disney and his own incredibly fertile

imagination, Tezuka created hundreds of characters—among them Astro Boy—and pioneered dozens of new techniques that burst out of the page, even in black and white.

Under his influence, and with the rich, postwar imaginations of his friends and colleagues, manga made a quantum leap in quality and popularity; it shattered into the dozens of thrilling genres and thousands of stories we know and love today.

The book you're now reading is designed to help you create the ultimate range of manga characters, whether to populate your own new stories; act as totemic mascots for your sports team, publication, or Web site; or even just to decorate your own range of T-shirts. The first half of the book is crammed with step-by-step tutorials designed to launch you into your new hobby, from using the CD included with the book and on into the fun part of combining, coloring, and customizing the artwork.

Take a deep breath—then come join the manga revolution!

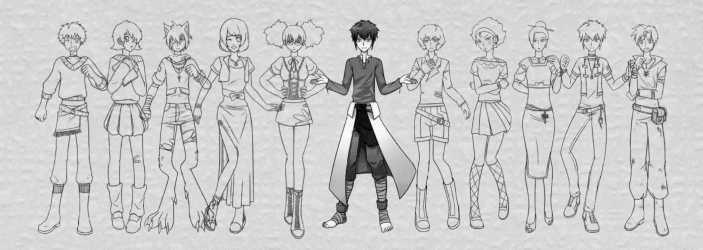

USING THE BOOK AND CD

Whatever the scale of your interest in manga—from creating iconic new characters for T-shirt designs to putting together finished pages of a story—you'll find everything you need in this book-and-CD collection, the ultimate introduction to creating any manga character you can imagine. The first half of the book features easy-to-grasp techniques for conjuring up new manga figures from the hundreds of thousands of options available, coloring them, and integrating them into your own scenes and pages, while the back half of the book contains just a taste of the manga potential you can unleash using the files on the CD.

Whether you're an accomplished manga-ka with dozens of designs under your belt or a newcomer to the art form looking for tips, this book is bursting with all the inspiration you need.

The CD itself contains hundreds of pieces of manga character art to recombine in over a million different ways: 100 heads, 100 upper bodies, and 100 lower bodies, all designed to splice together seamlessly in any combination you can imagine.

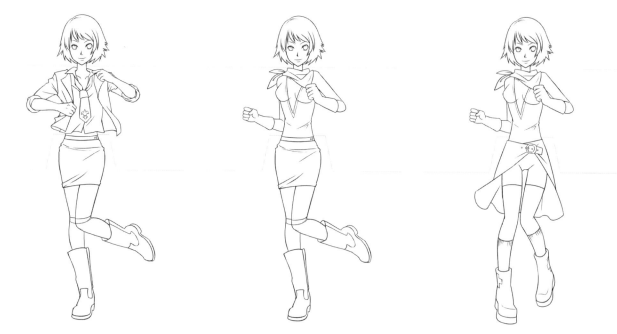

Taking It Further

If a million different characters aren't enough for you, there's no need to feel limited to the designs on the disc. Push yourself beyond your limits by adding your own flourishes and body parts, whether integrating scanned artwork or drawing digitally. There's no need to feel constrained to using the line art provided on the disc. Enjoy yourself, and let loose the master of manga inside!

creating manga figures

There are over a million different combinations of manga characters to create on the disc. Don't be daunted by the possibilities, though; the simple interface makes the process of choosing your iconic character painless! Simply insert the CD to launch the *One Million Manga Characters* program or click on the CD icon.

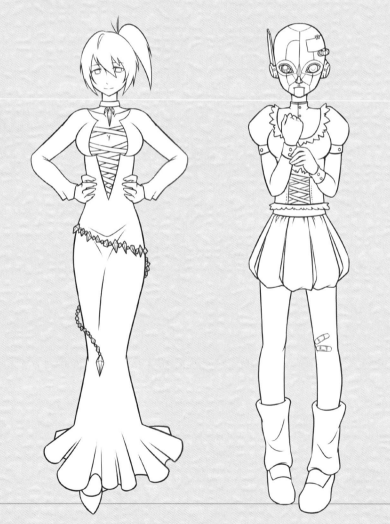

To create your own figure from the disc, you could start by choosing one of the predrawn designs from the back of the book and entering the matching codes on the drop-down menus. Alternatively, select your own elements from the three drop-down menus on the main interface. Just pick the *Head*, *Upper Body*, and *Lower Body* sections you desire.

Clicking the *Copy* button will save your design so that it can be pasted onto the clipboard and digitally colored or customized using a photo-editing program.

Clicking on the *Print* button will automatically print a black-and-white image of the manga figure that appears in the preview window. This can then be hand-colored using pens, pencils, or colored inks.

To select different panel designs at random, click on the *Lucky Dip* button.

The *Quit* button allows you to close the program.

The preview window displays the finished character, based on the selections from the drop-down menus.

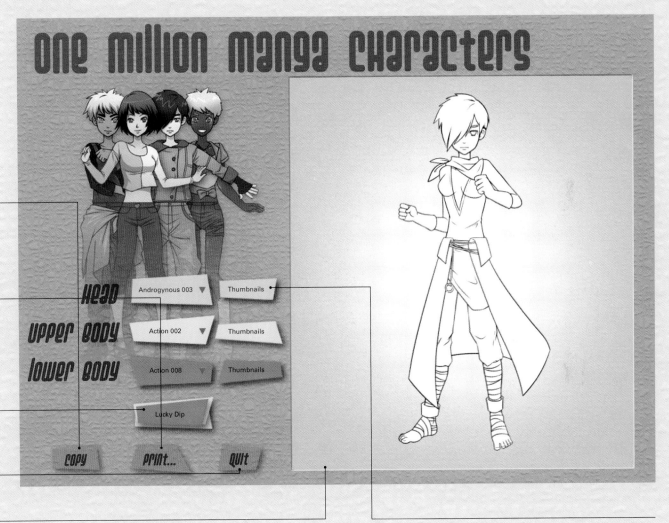

one million manga characters

HEAD	Androgynous 003 ▼ · Thumbnails
UPPER BODY	Action 002 ▼ · Thumbnails
LOWER BODY	Action 008 ▼ · Thumbnails
	Lucky Dip
	COPY · PRINT... · QUIT

View the different designs for the *Head*, *Upper Body*, and *Lower Body* by clicking on the *Thumbnails* icons next to the drop-down menus. Select a design to preview.

printing and saving

Printing is the easiest part of the process, after the difficult business of deciding on a design. One click on the appropriate button is all it takes to automatically print your new hero, but there are a number of ways to optimize your output after that.

Getting the Best from Your Printout

If you're going to use your character for something permanent, such as a decal, it's worth investing in a decent printout. If you're printing from home, make sure you've got fresh ink cartridges, and that you're happy with the way the design looks on paper compared to the screen. Bright white or glossy paper will display vibrant colors better.

A strikingly colored manga figure makes for an awesome T-shirt design. Why not try printing your favorite character onto transfer paper to expand your wardrobe with something eye-catching and original?

Inkjet printers create good-quality color prints, which can be improved further when printing on photographic paper. Alternatively, laser printers are great for printing black-and-white images as the lines are often crisper and the ink won't smudge from handling or when coloring with markers.

The following section deals with customizing your figures so you can create truly unique designs. You can do this by copying your design and pasting it onto the clipboard of an image-editing program, such as Adobe Photoshop, Photoshop Elements, or Corel's PaintShop. You may already have access to this software, but if not, it is easily available. Photoshop Elements is a condensed, cheaper alternative to the full-fledged program, but it is perfect for customizing your figures. The following techniques for designing your own figures are all examples from Photoshop Elements.

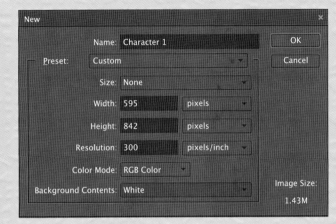

1. To import your figure into Elements, click on the Copy icon to copy your design to the clipboard.

2. Open Photoshop Elements and select File > New.

3. This will open the New Document dialog. Set the Color Mode to RGB, the Background to White, and click OK. You can also choose to set the Resolution of your image, although this is optional. Here it is set to 300 ppi. The higher the resolution, the "smoother" your line art will be.

4. Paste your figure into the New Document (press Ctrl/Cmd + V). This places your figure onto the clipboard as a "Vector Smart Object." Click on the tick in the Toolbar above your document, or press Return (Enter) to secure your figure vector to your page.

5. Next, "flatten" your image to a single layer by selecting Layer > Flatten Image from the menu, or by pressing Ctrl/Cmd + E. You can start coloring right away—just create a new layer and set it to Multiply if you want to quickly lay down some colors over the top of your linework—or you can try out some of Photoshop's settings to refine your line art first (see page 24).

Tip: Copying to Clipboard
There are many applications that allow you to paste your figure onto the clipboard. In Windows you can paste directly into Paint or even Microsoft Word. You can then save your figure and e-mail it to a friend!

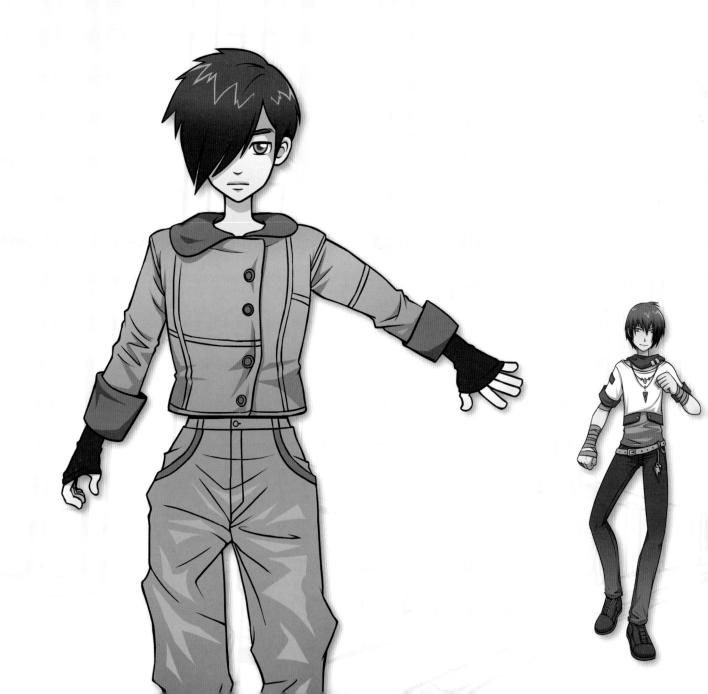

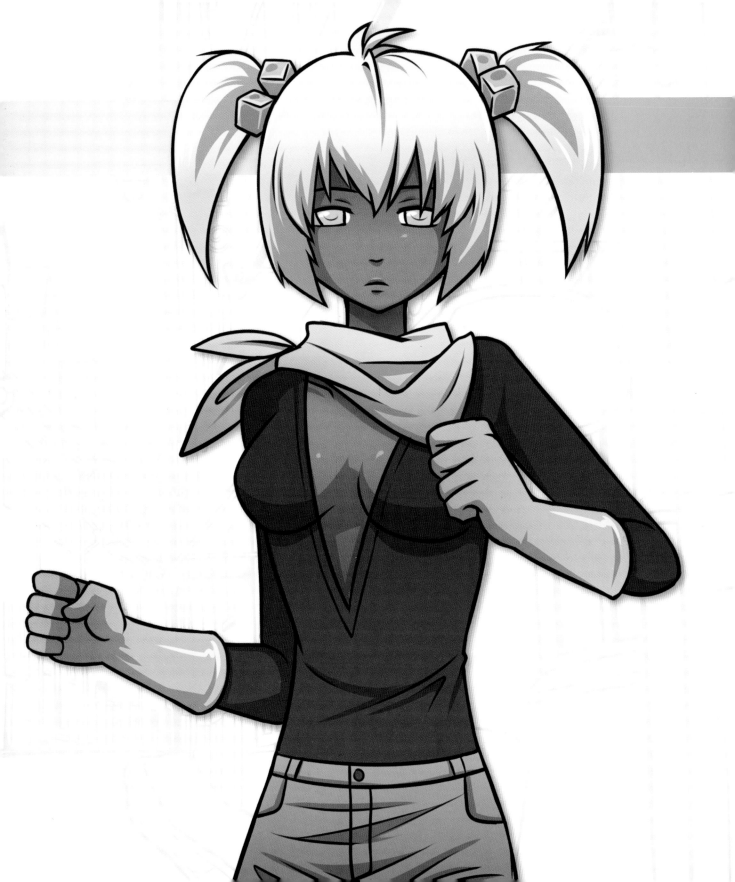

Basic Software

Photoshop and Photoshop Elements

Photoshop's range of cool and useful imaging tools make it perfect for illustration and coloring. The program comes in two versions: the full-featured image editor, and Photoshop Elements, a condensed, cheaper version for home use. But most editing programs are ideal for coloring your figure designs. Throughout this book we will use Photoshop Elements as an example.

Tool Options Bar
Here is where you fine-tune the tool you've selected. On the Brush tool, for example, you can select the size and opacity of the tip.

Toolbox
Although they differ slightly, both versions of Photoshop have a Toolbox, which by default appears on the left of the window. This is where you select different functions.

Palettes
These floating windows are palettes. The most useful is the Layers palette, which allows you to switch between different layers of your image—for instance, between your black-and-white design and the colors above or below it. Switch by clicking the box to the left of the layer: an eye icon means a layer is visible. The current layer is shown with a colored or darker bar.

Tip: Pixels
The larger the monitor, the more of your design you'll be able to fit on the screen at once. If you often zoom in and out to work on fine details, don't forget to keep checking your artwork at 100 percent to make sure you're happy with the balance of the image as a whole.

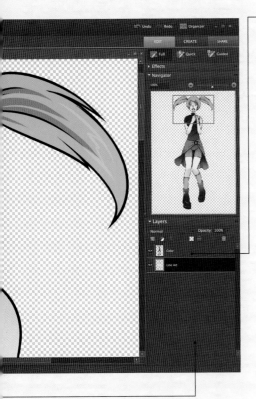

Layers

Layering is the most useful innovation of digital imaging, allowing you to stack different components on top of one another so that you can change each individual element—the colors or the linework for example—without impacting the rest of the picture. Think of your layers as microthin sheets of clear plastic, each stacked on top of one another like processed cheese squares. Each layer has a piece of the finished picture drawn on it and it's only when you look down on the whole stack that you see the finished piece. Because each layer can be edited, moved around, and tooled about with independently, you'll find yourself experimenting more, and working faster and better, all without the risk of spoiling your underlying artwork. Simply turn off layers if you don't like the results! You'll probably find yourself using more and more layers as you grow more comfortable with them, dedicating layers to specific areas of your image, such as shadows and highlights.

Navigator Window

This window lets you move around a document quickly without using the Toolbox or keyboard, and also lets you keep one eye on how your design looks as a whole, even when zoomed in.

Photoshop Tools

Check out the main tools in the Photoshop Elements Toolbox. You'll find very similar tools in Photoshop itself—we've covered the essentials available in both versions.

Terminology

Occasionally we'll drop a time-saving keyboard shortcut on you: while the letter is usually the same, control keys vary between Windows computers and Macs, so Ctrl/Cmd + Alt + C means to hold the keys marked Ctrl and Alt and tap C in Windows, but to use the keys marked Cmd and Alt and C on a Mac.

Navigation Tools

 Move

Click and drag to move the currently active layer or selection.

 Hand

The Hand tool lets you scroll around the image without moving the design itself. Useful if you're zoomed in! Press the space bar to activate it while coloring.

 Zoom

Zooming enlarges or reduces the preview of your image. Holding Ctrl/Cmd and pressing the + and – keys allows you to zoom in and out at any time. Pressing Alt and using the scroll wheel on your mouse does the same!

 Eyedropper

The Eyedropper tool changes the foreground color to one you click on (current colors are at the bottom of the Toolbox). The Alt key temporarily changes the Brush tool into an Eyedropper. Pressing X swaps your foreground and background colors, so you can pick up one color, flip, and pick up another!

Paint Tools

The paint tools are used to draw lines and add color to an image.

 Paintbrush

The standard painting, drawing, and coloring tool, useful for soft edges and smooth lines. A wealth of styles are available in the Tool Options bar.

 Pencil

The pencil creates pixel-perfect lines; the same as the Brush tool, only without any blurring or blending. It's great for fixing or altering your line art, or drawing clearly defined areas of color.

 Eraser

The Eraser works just like a normal eraser. On a flat image, it rubs away to the background. On a stacked layer, it will erase to show the layer underneath.

 Paint Bucket

This tool fills an area with a selected color. Click on an area and it will be filled to its edges (the point where an area of color meets another significantly different to its own—you can adjust this level of difference, called Tolerance, in the Tool Options bar).

Accurate selections mean quicker, more accurate coloring. Choose the tool that's right for you!

Marquee Tools

The simplest selection tools are the Rectangular and Elliptical marquees. Highlight a rectangle or ellipse on your document by clicking and dragging. Holding Shift while you drag gives a perfect square or circle.

Lasso Tools

These tools allow you precise control. The Freehand Lasso requires a constant, steady hand. The Polygonal Lasso creates a similar selection, but draws lines between waypoints you define, meaning you can lift your finger between clicks.

 Selection Brush

The Selection Brush, a Photoshop Elements exclusive, allows you to "draw" a selection directly onto your picture. Photoshop has the Quick Mask feature instead, where you can use the standard Brush to "paint" the mask on a new layer.

 Magic Wand

The Magic Wand tool allows you to select areas of a specific color in the image: great for selecting areas in your figure, and also for reselecting areas of flat colors once you have applied them.

Selection Areas

Selections are used to control which parts of your design are affected by your painting or coloring. A selection outlined by "marching ants" can be colored without affecting the areas around it—you can use it to quickly flood-fill areas rather than coloring large areas with the Brush tool. Selections are made and defined with a variety of tools—the Rectangular Marquee draws a simple box, while the Magic Wand selects areas of similar color, no matter the shape. Switch the Contiguous option on, and the Magic Wand can be used to select specific areas on your uncolored line art; turn it off to select all areas of a single color at once. Don't forget to switch off, or deselect your selection when you are finished with it—click outside the selection or choose Select > Deselect to do so.

Tip

Hold the Shift key when using a selection tool to add your new selection to an existing one. Hold Alt to delete from an existing selection. The + and − signs next to the mouse cursor indicate whether you'll add or subtract.

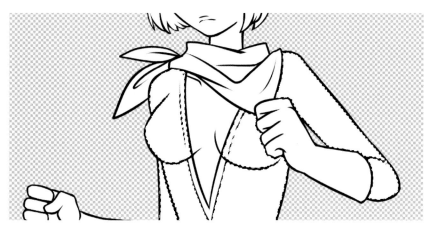

Basic tools

Basic Brushes

The Brush and Pencil tools are the most basic yet versatile ways of adding lines and color. Brush settings control whether a brush is opaque like paint or translucent like a marker pen, and whether it blends or overdraws. The nib can be blunt or pointed, or even made of a custom shape. You will probably only want to use the simplest and boldest settings when coloring your figures, but it never hurts to know what Photoshop is capable of!

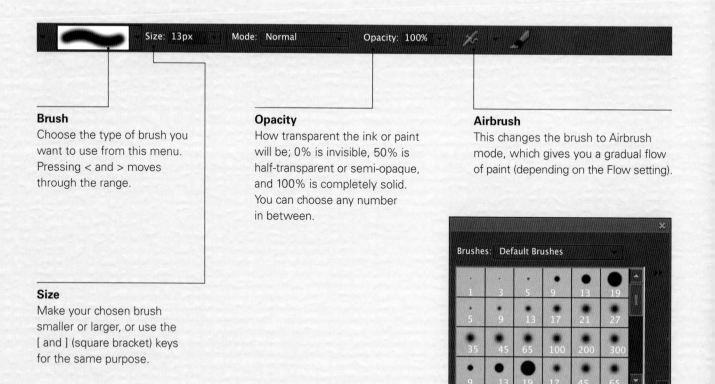

Brush
Choose the type of brush you want to use from this menu. Pressing < and > moves through the range.

Opacity
How transparent the ink or paint will be; 0% is invisible, 50% is half-transparent or semi-opaque, and 100% is completely solid. You can choose any number in between.

Airbrush
This changes the brush to Airbrush mode, which gives you a gradual flow of paint (depending on the Flow setting).

Size
Make your chosen brush smaller or larger, or use the [and] (square bracket) keys for the same purpose.

Brush Shapes

Hard brush (1)
These brushes give you a solid shape and smooth outline. The edge is softened, but still gives a sharp division between two colors.

Soft round (2)
These brushes have a gradient of density, their opacity reducing toward the edge of the basic shape, making them perfect for gently blending colors together.

Natural brushes (3 + 4)
You can emulate "natural media" such as paints, pastels, and charcoal with irregularly styled brushes. The brush menu contains a wealth of exotic patterns and shapes that may provide you with inspiration.

Keyboard Shortcuts

Quick Brush Resizing
The [and] keys quickly resize your brush (holding down the Shift key at the same time lets you alter the hardness). This lets you rapidly adjust your level of detail without having to zoom out or shift your focus from a tricky part of the character.

Quick Color Changes
When working with the Brush or Pencil tools, you'll often want to change color quickly. By holding the Alt key and clicking over a pixel of the color you want, you pick up that color from the canvas. (You might even want to keep some dabs of color on your image to choose from until you're done.) Another good friend is the X key, which quickly alternates between the foreground and background color.

Painting with Opacity Controls
The number keys along the top of the keyboard act as handy shortcuts for adjusting the opacity of your brush. Press 1 for 10% opacity, 2 for 20% opacity, etc. If you press 2 and 5 quickly, you'll get an opacity of 25%. This is useful if you want to introduce some blending or subtlety to your coloring, but don't want to change color. These shortcuts, combined with the X button, can allow for very fast monochrome coloring!

Basic Techniques

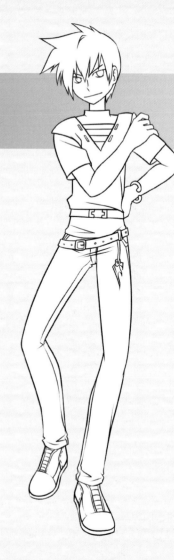

Resizing, Rotating, and Flipping

You can use the Free Transform tool (Edit > Free Transform, or keyboard shortcut Ctrl/Cmd + T) to personalize your favorite character designs even further. Select an area of the line art using any of the selection tools (the Marquees are most useful), then rotate, resize, or mirror that element using the Free Transform tools, or the Transform Controls indicated by white control points around the border of your selection.

 If the Transform Controls aren't visible, turn them on by creating a selection, switching to the Move tool (press V), then checking the box marked Show Transform Controls in the Tool Options bar.

 The only disadvantage of Transforming a black-and-white image is that you'll anti-alias (soften and blur) parts of your picture: this can make "flood fills" when coloring with the Paint Bucket less effective. You can remove anti-aliasing by adjusting the Threshold of your line art (see Step 2 on page 24).

→ **1.**
Select the portion of your image you want to rotate or change in size (scale) by drawing a selection around it, switching to the Move tool, and choosing Free Transform or Transform > Scale—or use the Transform control points that appear around the selection.

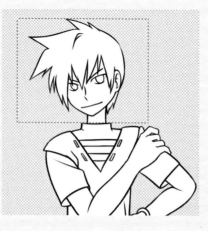

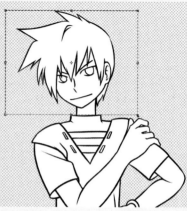

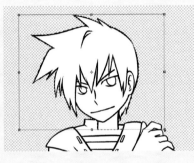

↑ 2.

Use the white control points at the corners of the selection to drag it larger or smaller (holding down Shift as you do so will keep the selection in proportion), or enter a percentage in the Tool Options bar.

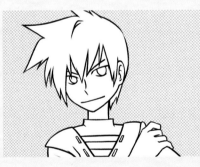

↑ 3.

When you've finished adjusting your image, press the Enter key or the tick icon on the right side of the Tool Options bar. If you're not happy with it, click the red cancel icon and your selection will jump back to its original state.

→ 4.

To rotate a selection, you can choose Edit > Transform > Rotate, or, with Show Transform Controls enabled, hover the mouse just outside one of the corners of the bounding box until the cursor turns into a curved, two-ended arrow. Dragging to the left or right rotates the whole selection— you can also enter precise degrees in the Tool Options bar. Here the Polygonal Lasso tool has be used to plot a selection around the face.

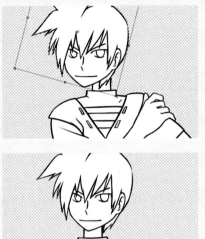

↓ 5.

Flipping (or mirroring) your image is also an ideal way to double your character options. Do this by selecting Image > Rotate > Flip Horizontal. To mirror only a selected part of the image, use Edit > Transform > Flip Horizontal / Flip Vertical.

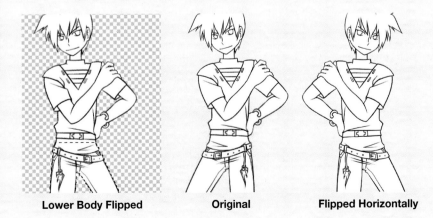

Lower Body Flipped **Original** **Flipped Horizontally**

blocking in color

Filling in base colors is the first step in every coloring process. Flat colors block out the areas of color that serve as boundaries for the more detailed coloring to follow.

It doesn't always follow that the most complicated or rendered form of coloring is the best. Simpler, bolder designs with limited numbers of colors will often be more striking and attractive—sometimes flat colors will be all you need. Experiment with amounts of color to find the style that suits you best.

Creating blocks of solid color on a separate layer also allows you to reselect large areas of color with the Magic Wand tool with the greatest of ease—keep a copy of your flats layer, even after you start shading, so that you can come back to areas of color later if you aren't happy with them.

Preparing the Artwork for Color

When you have copied your character and pasted it into your application, you should prepare it to be colored or toned. It's important to make sure that no anti-aliasing is present, as blurred lines can prove tricky during coloring.

1. Choose Layers > Flatten Image from the menu. This will reduce the image to a single layer.

2. Choose Filter > Adjustments > Threshold. Adjust the slider until you are happy with the "boldness" of your lines. This means that any colors above a certain percentage of darkness will become black, and any below will be white.

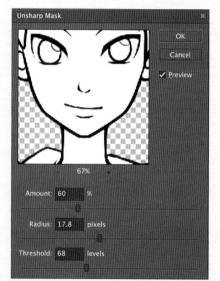

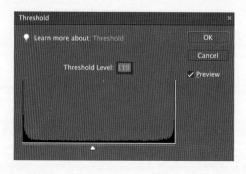

As well as setting your resolution, another way to optimize your line art is to try out some of Photoshop's Sharpen filters, such as the Smart Sharpen filter. Or in Elements, apply the Sharpen effect.

Laying Down Flat Colors

← 1.

All of the character designs have solid black lines for easy coloring. If you wish, you can just use the Paint Bucket tool set to Contiguous to fill them. If you want a little more control, duplicate the line art to a new layer. Using the Magic Wand tool, with Contiguous unchecked, click on an area of white, then press delete. This will select and delete anything that isn't line art. Delete the artwork on the original line art layer, replacing it with a flood fill in a neutral color, such as gray or pale yellow.

↑ 2.

On the line art layer, use the Magic Wand tool to select an area you want to block color in. Set the tolerance to about 35, check Contiguous, and uncheck Anti-alias. Press and hold the Shift key to select multiple areas (all of a character's skin tones, for instance) or press and hold the Alt key to deselect areas you may have clicked by accident.

↑ 3.

Now click Select > Modify > Expand, set the value to 1 and click OK. This expands the area of color out over the linework so that there are no gaps in the color when printed or viewed on screen. When you've finished selecting one group of areas, switch to the color layer below.

↑ 4.

Using the Paint Bucket tool, fill the selected area with your chosen color. You can also get the same result by pressing "X" to switch your chosen color to the background color, and pressing delete. It's quicker over multiple areas!

blocking in color

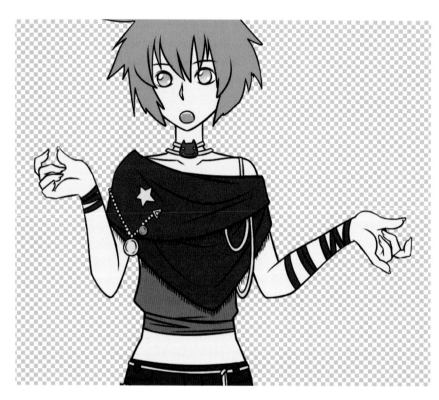

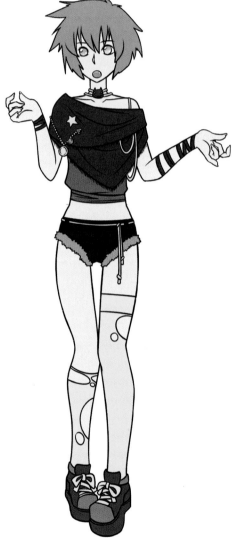

↑ 5.
Repeat the above steps to fill in all the colors. Coloring is time-consuming but always worth it!

→ 6.
Sometimes you will want to use the Pencil tool to fill in small problem areas not easily selectable, or areas not fully enclosed by the line art. Use the [and] keys, or the right-click menu, to increase or decrease the brush size.

↑ 7.
Use the Eraser tool to clean up any overlapping areas.

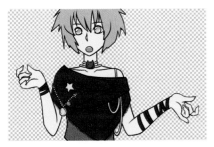

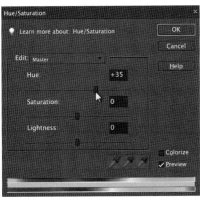

↑ 8.

If one color you have filled looks out of place next to another, you can adjust it. Use the Magic Wand to select the area of color you want to change (if you've used the color in more than one location on your page, deselect Contiguous and the Wand will select all the places where that color appears) then go to Image > Adjustment > Hue/Saturation and push and pull the sliders until you're happy with the new color. You can also use the same command to change the Hue and Saturation of your entire image.

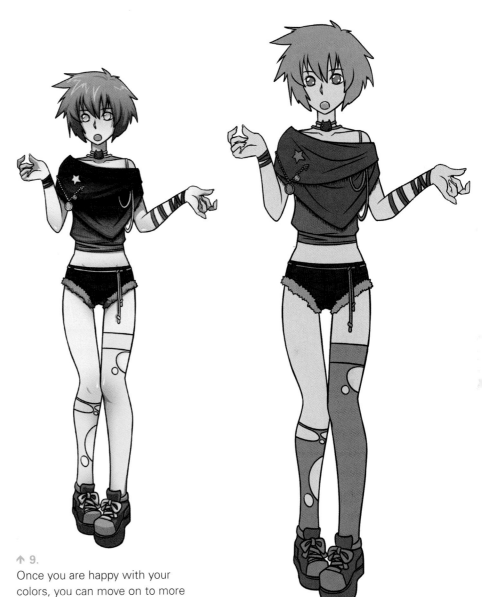

↑ 9.

Once you are happy with your colors, you can move on to more complex shading.

Shading and Highlights

Although flat colors work well with bold and simple designs, sometimes you may want something more complicated—perhaps to replicate the look of anime cartoons, or to better integrate a character with a photographic or painted background. Anime-style coloring uses flat colors to denote light and shade with two-tone, high-contrast shading, while natural media coloring uses a finer, more gradated range of colors to produce a more lifelike effect.

The brushes in Photoshop make shading with airbrush and simulated natural media effects easy! These natural effects, due to their use of hundreds of colors, can produce much more dimensional images.

→ 1.

After blocking in base colors, duplicate the layer (Layer > Duplicate Layer). Rename the duplicate and leave its mode on normal, then move it above your base layer. Keep the original base layer, as it will help you select areas of flat color with the Magic Wand. You will be doing all of your painting on the duplicate. Don't use the Eraser to correct mistakes, as it will erase through to the layer below: use a brush to paint over the fault with the original color.

↑ 2.

Select the color you want to work on using the Magic Wand with Contiguous unchecked. Choose a color that's a few shades darker (not a shade of gray). With the Paint Brush tool, select a soft tip and set the opacity to around 30%.

You can paint directly onto the color within your Magic Wand selection (selecting each area of color keeps your shading inside the lines). With an opacity as low as 30%, you can build darker color up gradually.

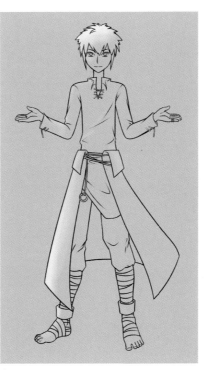

↑ 5.

Pay attention to the material you're painting, and how reflective or shiny it might be. Use the Hue/Saturation controls to tweak finished areas until you're satisfied. Here's where keeping your base colors as a separate layer comes in handy: painted colors are tough to select in their entirety with the Magic Wand. Just click back to the base layer, select the area of flat color you want to adjust, then flip back to the color layer to alter the selection as necessary.

↑ 3.

To add darker shadows, you can continue to gradually build on your shading with darker colors, or you could use a hard-edged brush with a much higher opacity to create stronger contrasts, like in anime-style shading. Think about where your light source is coming from, and where the shadows would fall on your figure.

↑ 4.

Once the shadows are complete, move on to the highlights—choose a lighter color than the original, or white, and paint areas that especially catch the light. Build the highlights up gradually with a soft-tipped, low-opacity brush.

It might help to check these against a color background. Create a new layer below your highlights layer and fill this with a solid color using the Paint Bucket tool while the other layers are turned off.

↓ 6.

When you finish coloring your image, add the strong highlights as the last step. Create a new layer on top of the color layer, name it "Strong Highlights," and leave the mode as Normal.

Pick a hard-tipped Brush and set the opacity to 80%–100%, then paint in bright white shades to finish your piece.

adding figures to artwork

After creating your figure you can add it into any existing artwork using the same programs you have used for coloring, such as Photoshop. Make sure that your background image and your figure are the same mode (either RGB or CMYK) and the same resolution, otherwise your figure will be too large and will be cropped or pixelated. Either copy and paste your finished file into a new window or drag your character layer onto your background image.

You can use any background image to place your figures against—whether an image you've drawn yourself, or an altered photograph, as explained on pages 32 and 33.

↑ 1.

↑ 2.

Copy your finished character design to your Clipboard as a new image. You may want to color it beforehand, as it may be very difficult to color once resized; flatten the colored image into a single layer before transferring it to your background. Either drag your character layer to your background image, or drag your character over with the Move tool, using the Magic Wand tool to select the flattened character art, then choosing Select > Inverse (Shift + Ctrl/Cmd + I) to get a precise selection of your figure.

Use the Free Transform tool (see page 22), or the Transform Controls, to scale and rotate the character appropriately, and place it where on the background drawing you want it to go; experiment to find the best positions and sizes.

→ 3.

Coloring a character beforehand will also allow you to choose complementary tones with which to color your background. You can color it using the same techniques you used on the figures earlier. Just temporarily turn off the figure layer if it gets in the way!

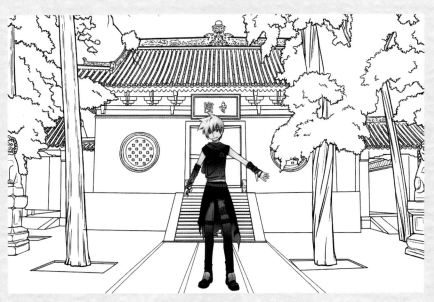

→ 4.

Adding multiple characters to a scene will allow you to play with a sense of scale. Arrange characters from close-up to the "camera" to the far distance to lead your viewer's eye around the drawing.

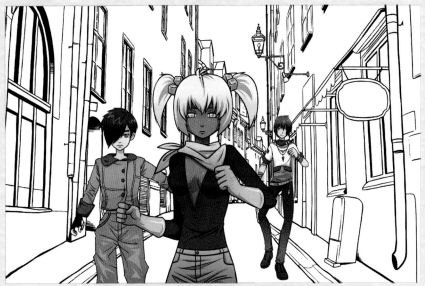

creating Backgrounds

If you're looking for a way to quickly create a range of awesome backgrounds for your new heroes and heroines, but aren't confident or time-rich enough to sit down at the drawing board, you can conjure up great results with your camera and a few Photoshop tricks! Here are two easy methods showing how to transform your favorite shots into stunning background scenes.

Method One

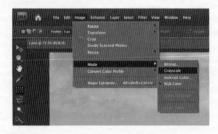

↑ 1.
Scan a photo, or import one from a digital camera, and open it in Photoshop. For our purposes, the bigger the photo is, and the higher the resolution, the better.

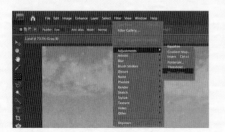

↑ 2.
Change the photo into grayscale (Image > Mode > Grayscale).

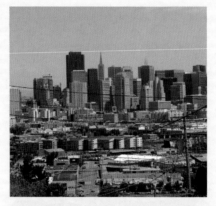

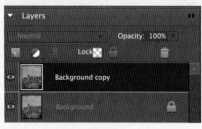

↑ 3.
Duplicate the layer. This keeps your original image for reference at the bottom of the Layer palette, which can be useful if you need to check details or even start the process again.

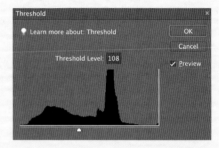

↑ 4.
Click Filter > Adjustments > Threshold (or Image > Adjustments > Threshold in Photoshop). An option window will appear. Slide the bar inside it—try to find a position on the slider that best approximates line art. For this particular photograph, a Threshold of 108 produces the optimum result.

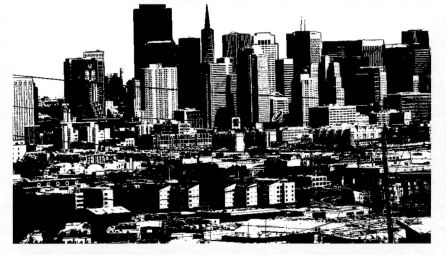

Method Two

1. Follow steps 1–3, as on page 32.

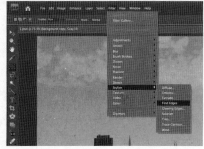

↑ 4.
Click Filter > Stylize > Find Edges.
The photo is converted into line art.

↑ 5.
Set the layer's Blending mode to
Multiply. This will reveal the original
photo underneath—you may want to
alter the Opacity of your converted
image. Compared to the original, you
can see a lot of detail has been lost in
the conversion. Click over to the Pencil
tool, and use black and white colors to
add back essential bits of detail and
clean up areas that look too messy.

↑ 6.
Turn Multiply off, flatten the layers,
and your background is ready to use!

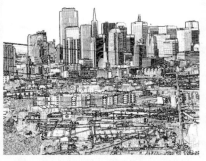

↑ 5.
This method keeps a lot more detail
than the first, but the finished result
is visibly messier. Just like in the first
method, use the Pencil tool to control
the level of detail. Adjust and redraw
until you're happy, then merge the
layers as before.

Tip
There are many different filters in Photoshop, and plenty of them will help
you transform your photos into perfect background material. Don't be afraid
to experiment! Adjusting the Levels (Image > Adjustments > Levels) of a raw
grayscale photograph may give you cleaner results.

the figures

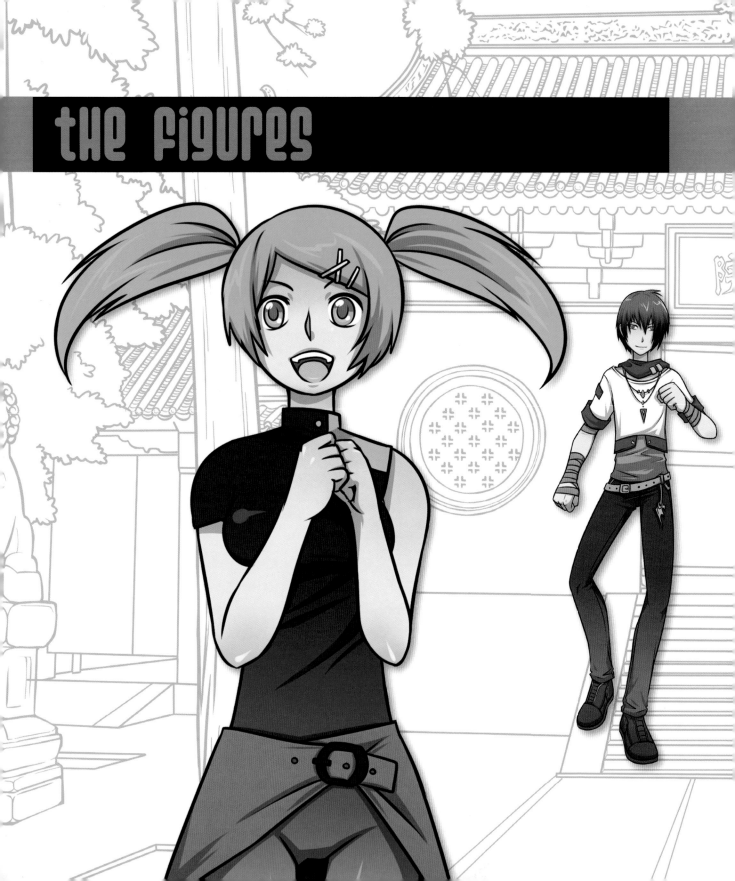

CONTEMPORARY SHOUJO

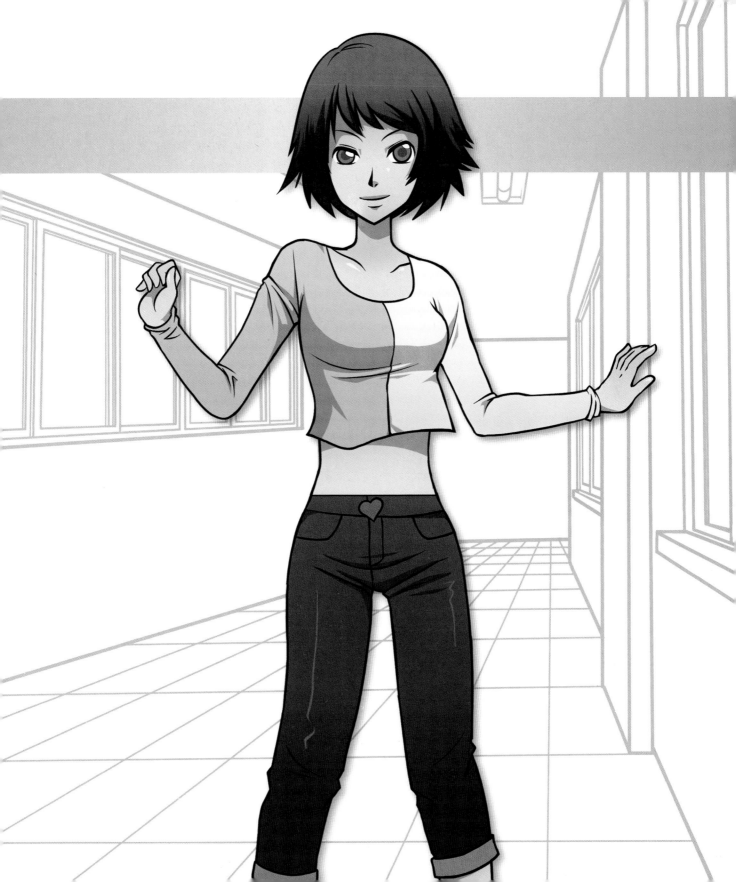

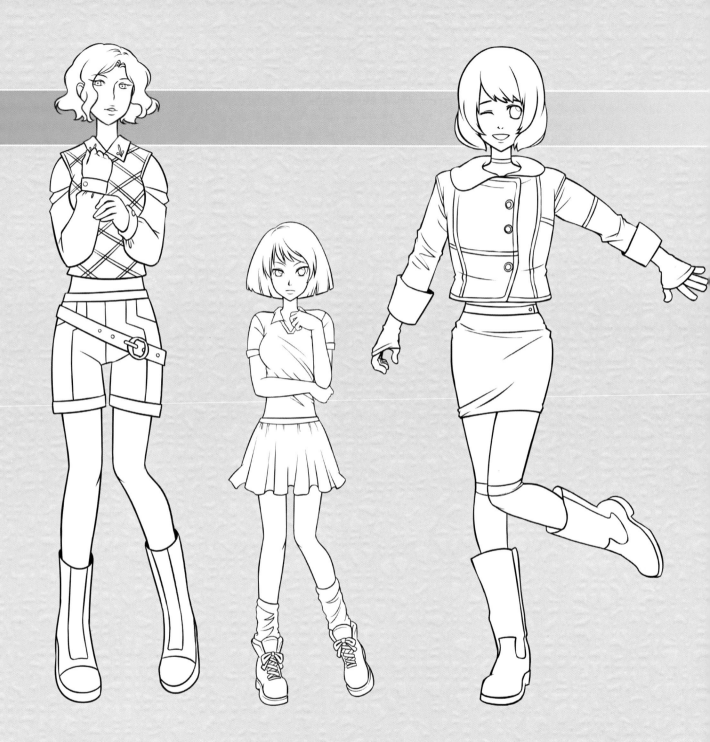

Head: *Female 036*
Upper Body: *Formal 002*
Lower Body: *Casual 008*

Head: *Female 005*
Upper Body: *Casual 004*
Lower Body: *Feminine 001*

Head: *Female 001*
Upper Body: *Casual 003*
Lower Body: *Feminine 002*

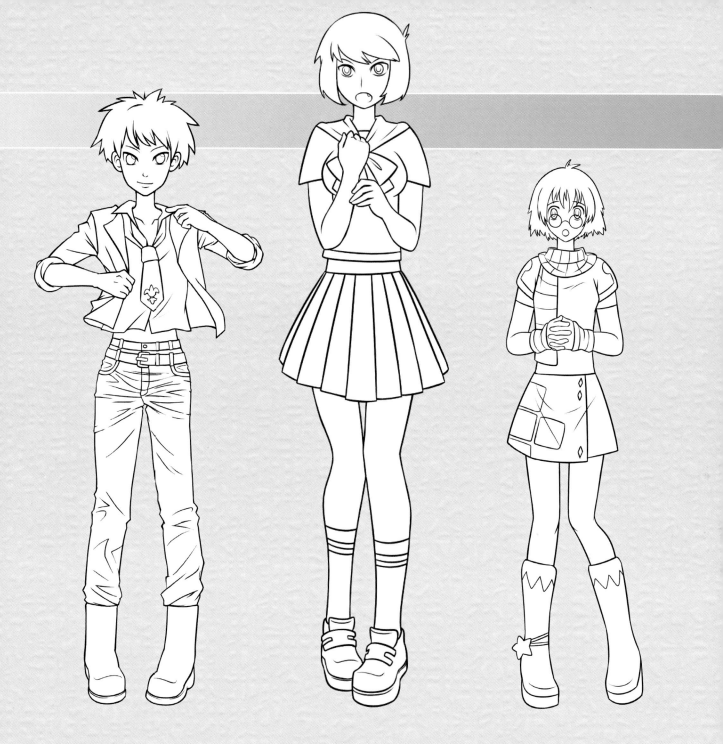

Head: *Androgynous 001*
Upper Body: *Casual 002*
Lower Body: *Casual 001*

Head: *Female 026*
Upper Body: *Feminine 022*
Lower Body: *Casual 015*

Head: *Female 029*
Upper Body: *Casual 018*
Lower Body: *Casual 013*

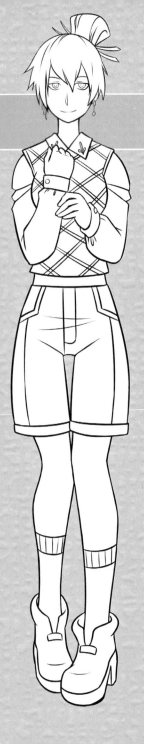

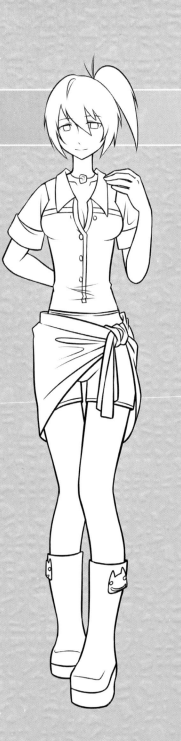

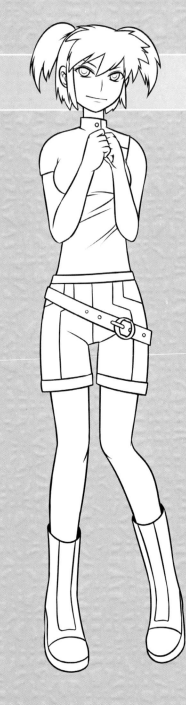

Head: *Female 022*
Upper Body: *Formal 002*
Lower Body: *Casual 011*

Head: *Female 024*
Upper Body: *Casual 012*
Lower Body: *Goth 007*

Head: *Female 014*
Upper Body: *Feminine 014*
Lower Body: *Casual 008*

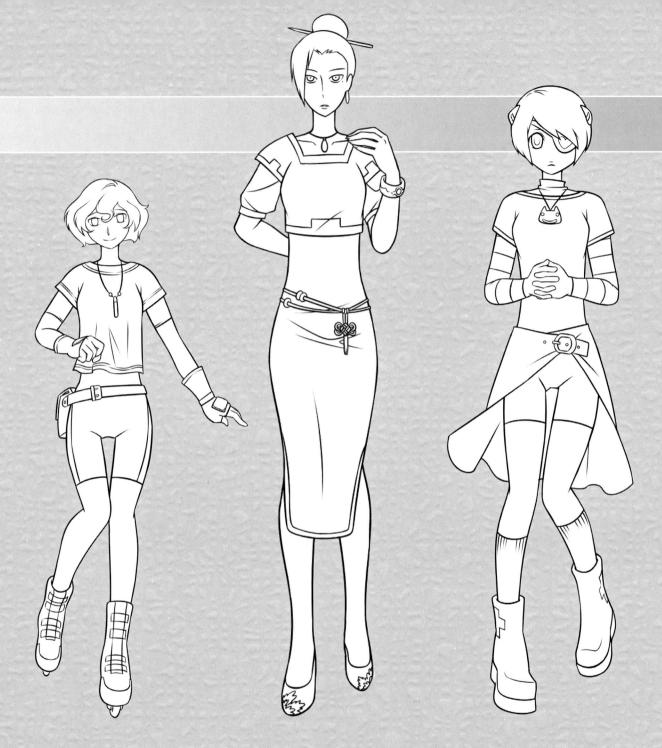

Head: *Female 023*
Upper Body: *Casual 014*
Lower Body: *Action 011*

Head: *Female 038*
Upper Body: *Feminine 004*
Lower Body: *Feminine 015*

Head: *Fantasy 003*
Upper Body: *Casual 011*
Lower Body: *Action 007*

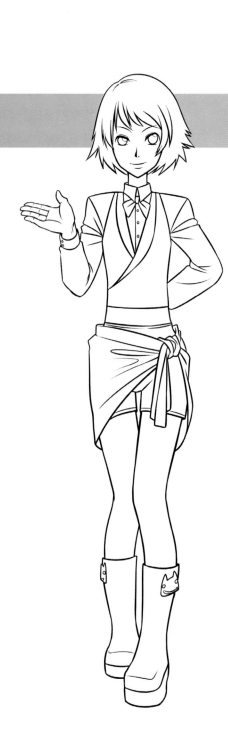

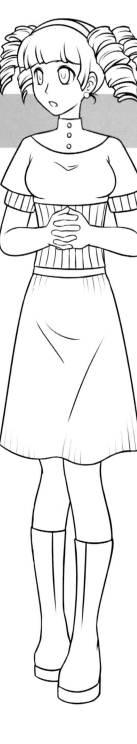

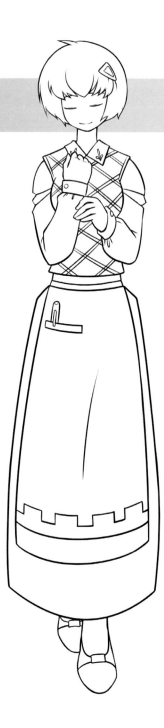

Head: *Female 003*
Upper Body: *Formal 004*
Lower Body: *Goth 007*

Head: *Female 013*
Upper Body: *Feminine 006*
Lower Body: *Casual 003*

Head: *Female 009*
Upper Body: *Formal 002*
Lower Body: *Work 003*

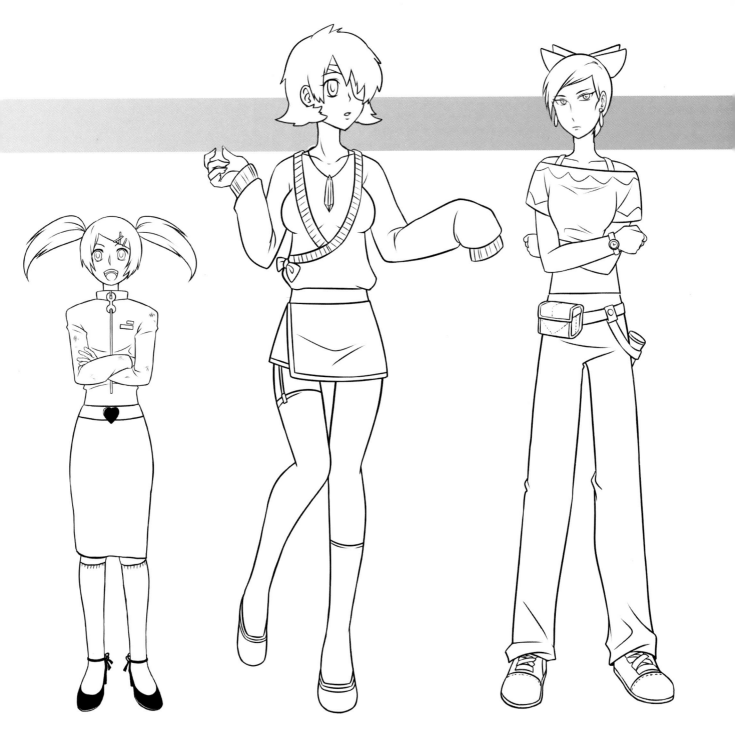

Head: *Female 015*
Upper Body: *Casual 020*
Lower Body: *Feminine 013*

Head: *Female 006*
Upper Body: *Casual 013*
Lower Body: *Feminine 009*

Head: *Female 037*
Upper Body: *Casual 017*
Lower Body: *Casual 016*

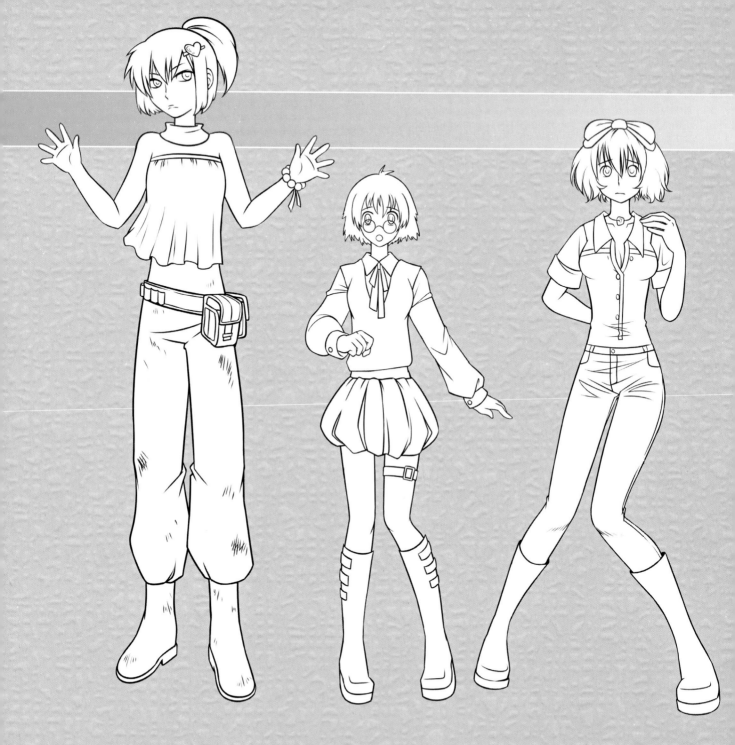

Head: *Female 012*
Upper Body: *Feminine 007*
Lower Body: *Action 014*

Head: *Female 029*
Upper Body: *Formal 001*
Lower Body: *Punk 009*

Head: *Female 033*
Upper Body: *Casual 012*
Lower Body: *Action 003*

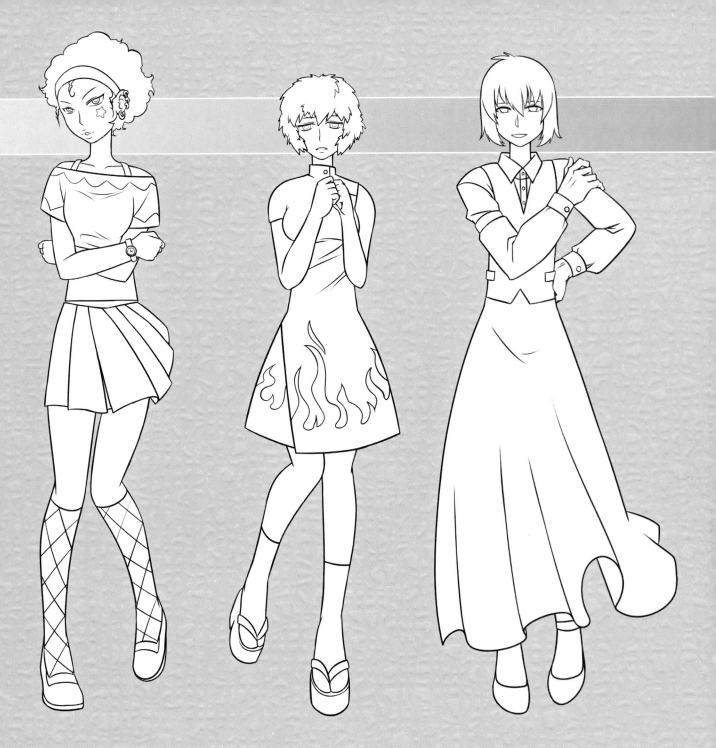

Head: *Female 032*
Upper Body: *Casual 017*
Lower Body: *Punk 001*

Head: *Androgynous 012*
Upper Body: *Feminine 014*
Lower Body: *Feminine 016*

Head: *Female 027*
Upper Body: *Formal 005*
Lower Body: *Feminine 010*

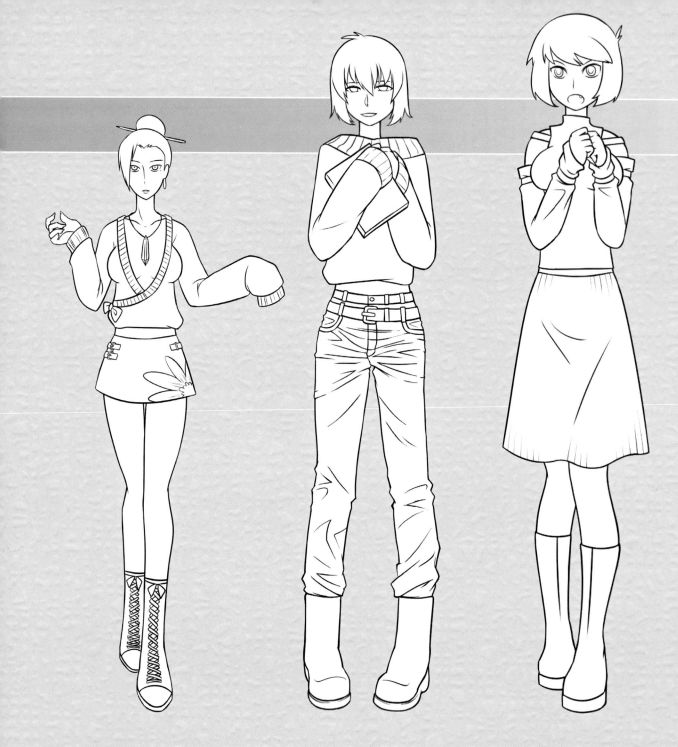

Head: *Female 038*
Upper Body: *Casual 013*
Lower Body: *Feminine 011*

Head: *Female 027*
Upper Body: *Casual 005*
Lower Body: *Casual 001*

Head: *Female 026*
Upper Body: *Goth 008*
Lower Body: *Casual 003*

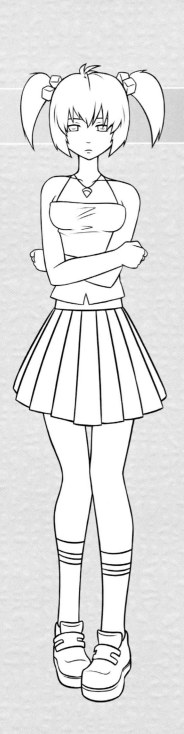

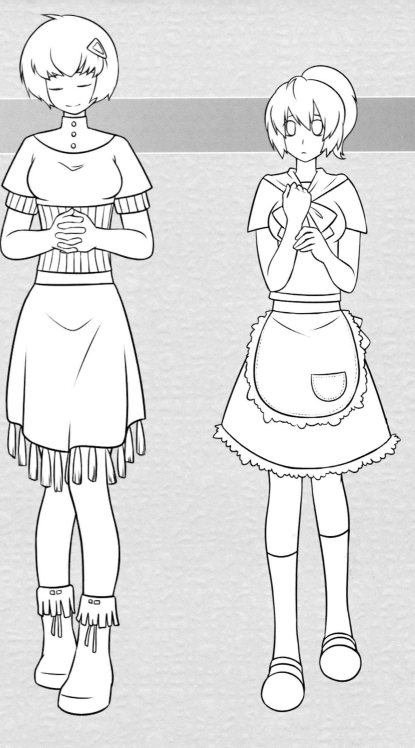

Head: *Female 007*
Upper Body: *Feminine 008*
Lower Body: *Casual 015*

Head: *Female 009*
Upper Body: *Feminine 006*
Lower Body: *Casual 014*

Head: *Female 010*
Upper Body: *Feminine 022*
Lower Body: *Feminine 008*

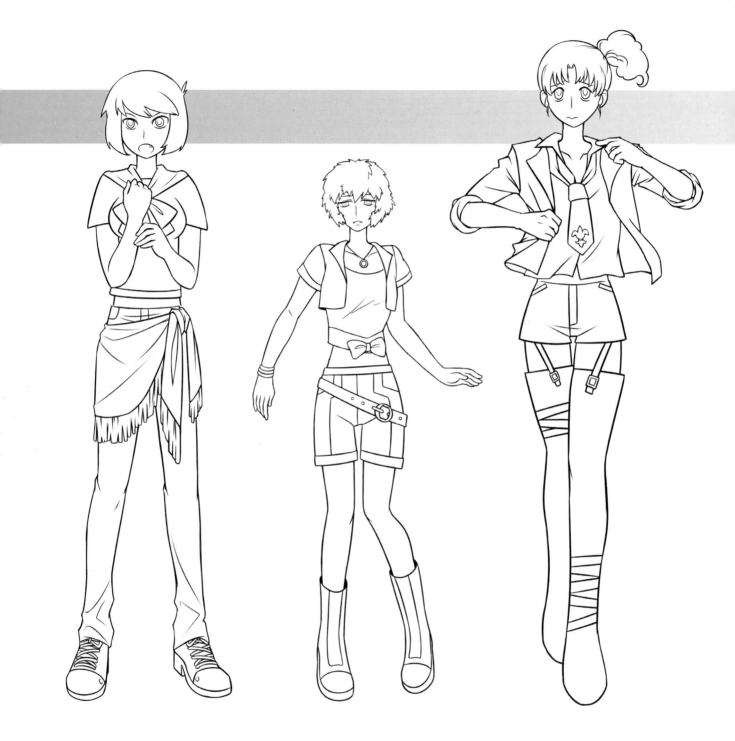

Head: *Female 026*
Upper Body: *Feminine 022*
Lower Body: *Casual 007*

Head: *Androgynous 012*
Upper Body: *Feminine 003*
Lower Body: *Casual 008*

Head: *Female 028*
Upper Body: *Casual 002*
Lower Body: *Punk 012*

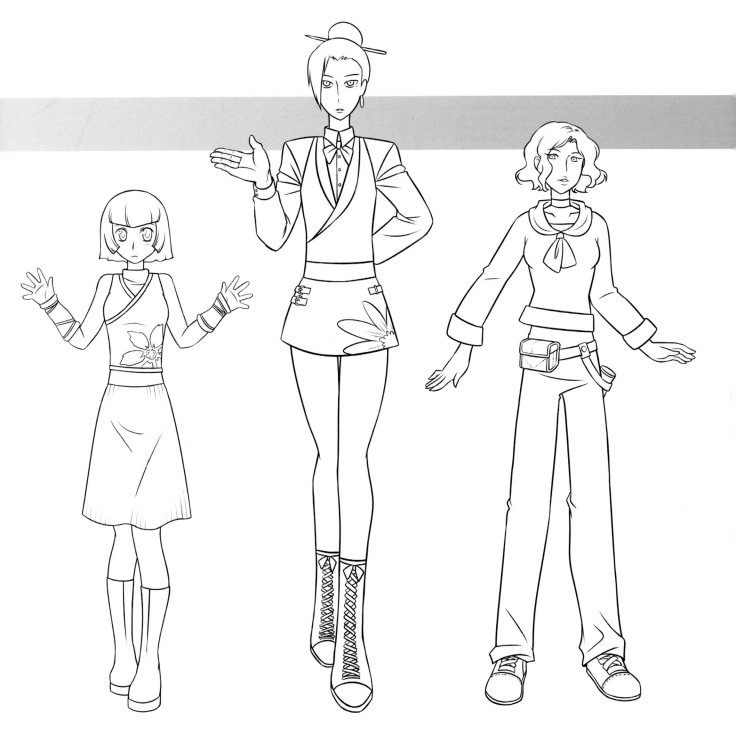

Head: *Female 011*
Upper Body: *Feminine 013*
Lower Body: *Casual 003*

Head: *Female 038*
Upper Body: *Formal 004*
Lower Body: *Feminine 011*

Head: *Female 036*
Upper Body: *Feminine 020*
Lower Body: *Casual 016*

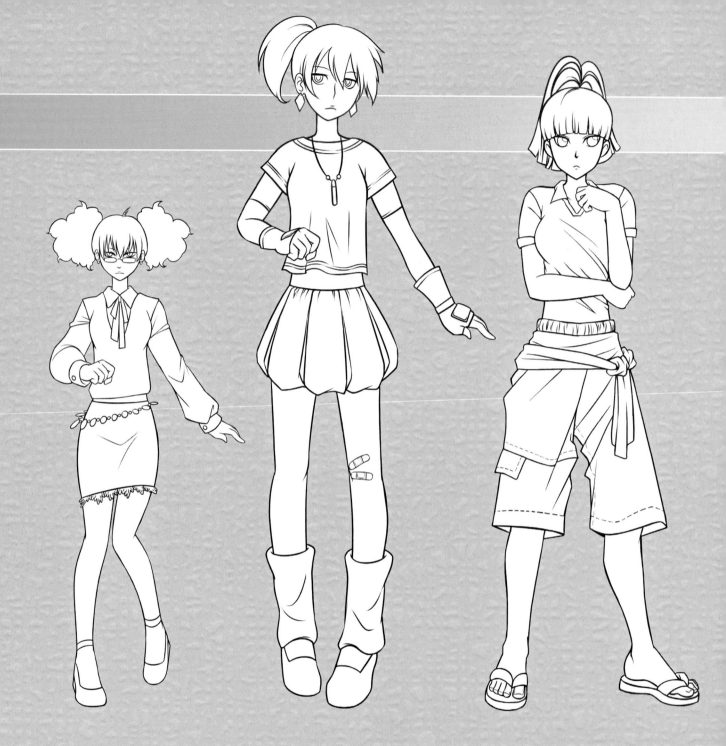

Head: *Female 019*
Upper Body: *Formal 001*
Lower Body: *Feminine 012*

Head: *Female 031*
Upper Body: *Casual 014*
Lower Body: *Feminine 005*

Head: *Female 002*
Upper Body: *Casual 004*
Lower Body: *Casual 002*

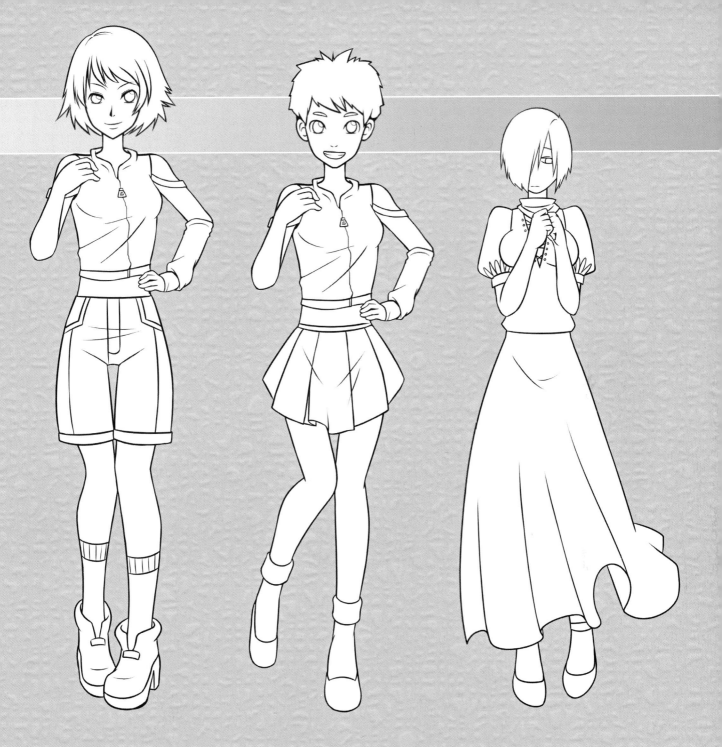

Head: *Female 003*
Upper Body: *Feminine 002*
Lower Body: *Casual 011*

Head: *Androgynous 002*
Upper Body: *Feminine 002*
Lower Body: *Feminine 006*

Head: *Androgynous 021*
Upper Body: *Feminine 019*
Lower Body: *Feminine 010*

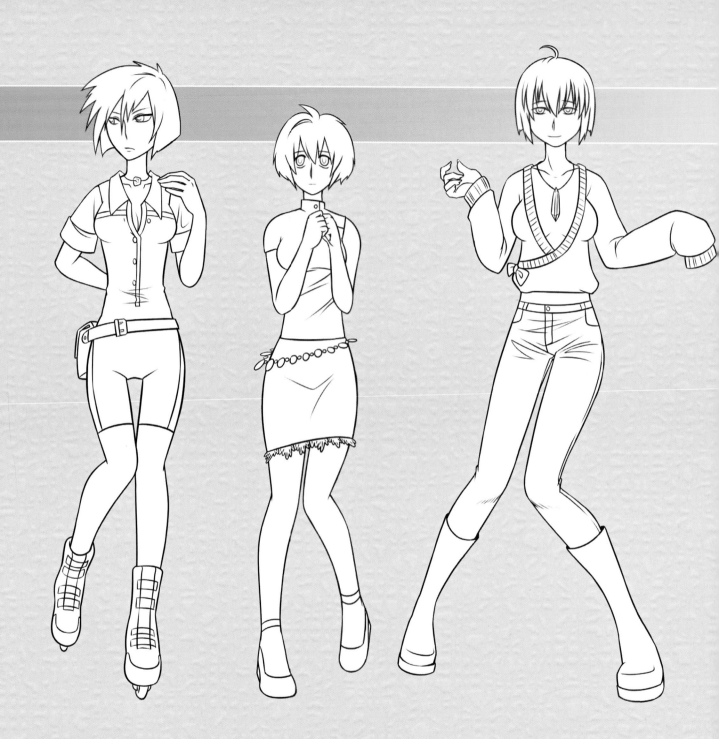

Head: *Androgynous 018*
Upper Body: *Casual 012*
Lower Body: *Action 011*

Head: *Androgynous 015*
Upper Body: *Feminine 014*
Lower Body: *Feminine 012*

Head: *Androgynous 005*
Upper Body: *Casual 013*
Lower Body: *Action 003*

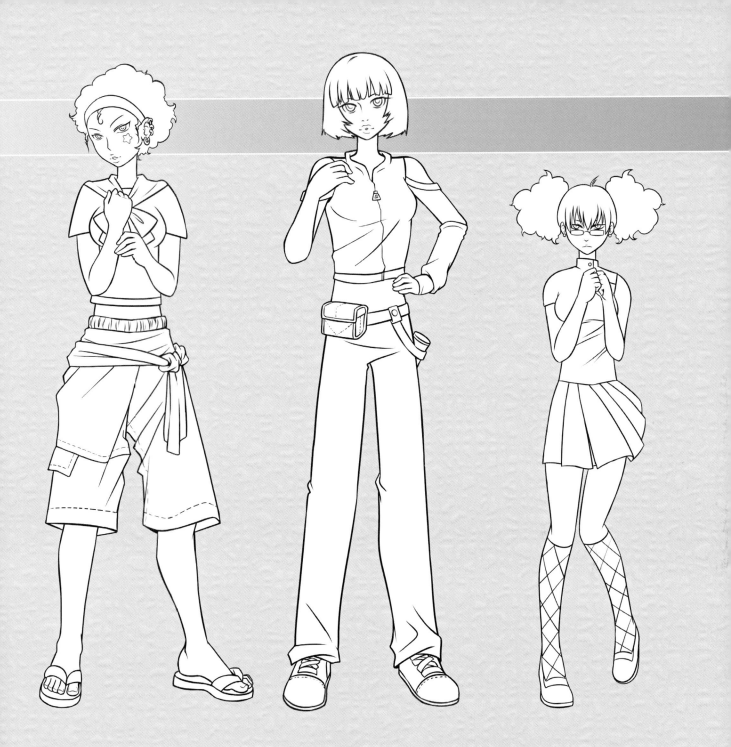

Head: *Female 032*
Upper Body: *Feminine 022*
Lower Body: *Casual 002*

Head: *Female 018*
Upper Body: *Feminine 002*
Lower Body: *Casual 016*

Head: *Female 019*
Upper Body: *Feminine 014*
Lower Body: *Punk 001*

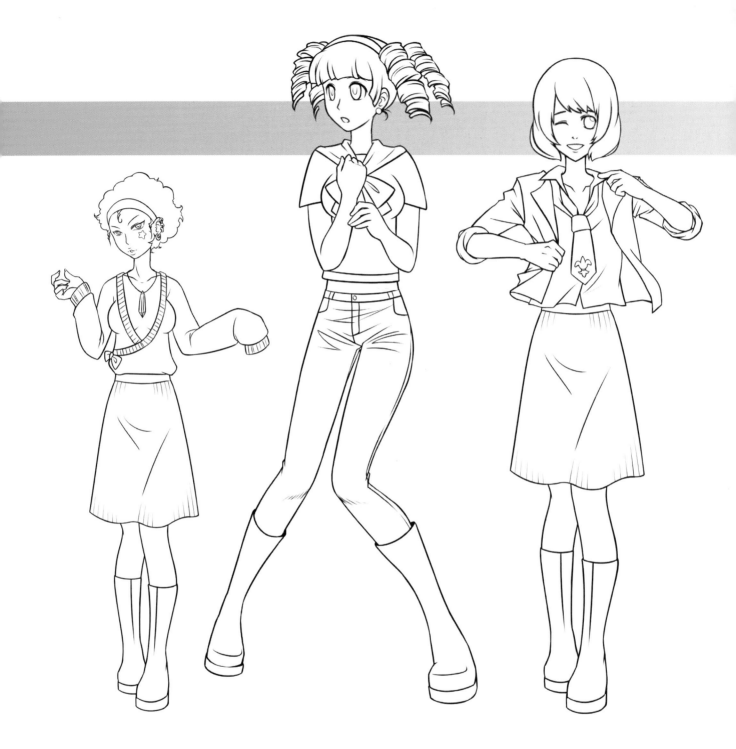

Head: *Female 032*
Upper Body: *Casual 013*
Lower Body: *Casual 003*

Head: *Female 013*
Upper Body: *Feminine 022*
Lower Body: *Action 003*

Head: *Female 001*
Upper Body: *Casual 002*
Lower Body: *Casual 003*

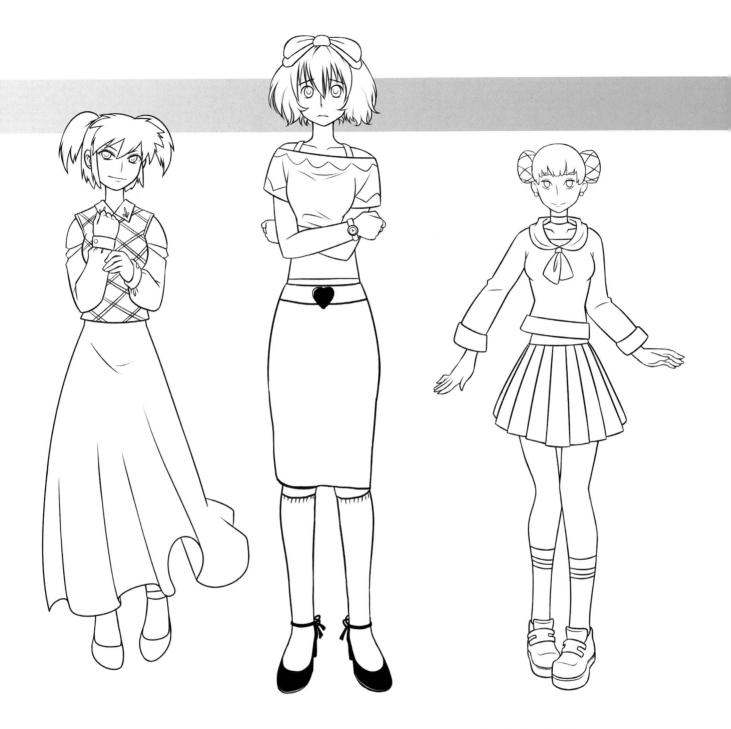

Head: *Female 014*
Upper Body: *Formal 002*
Lower Body: *Feminine 010*

Head: *Female 033*
Upper Body: *Casual 017*
Lower Body: *Feminine 013*

Head: *Female 030*
Upper Body: *Feminine 020*
Lower Body: *Casual 015*

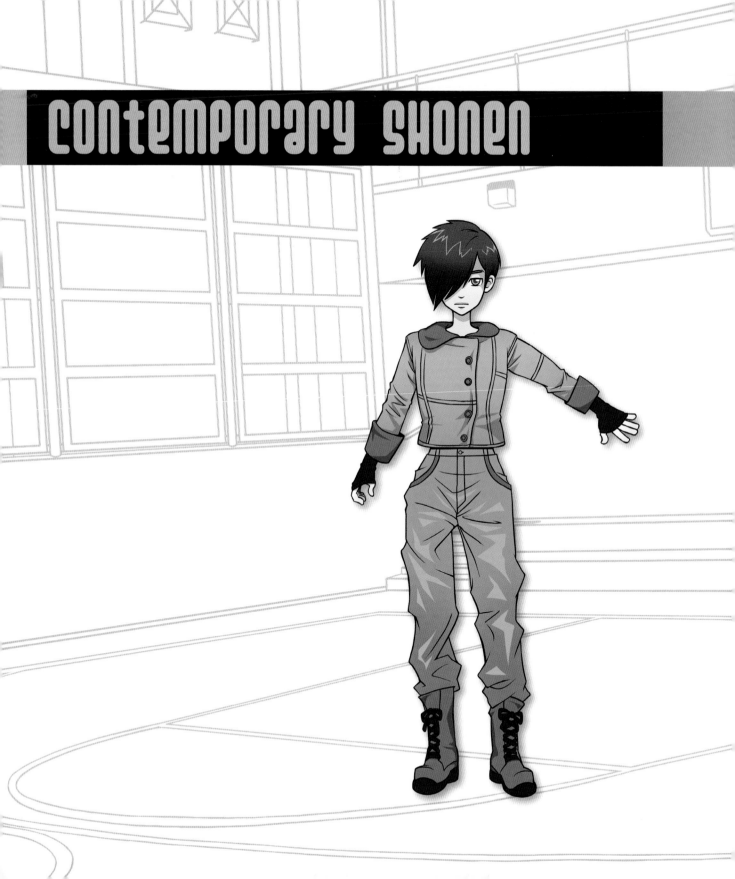

CONTEMPORARY SHONEN

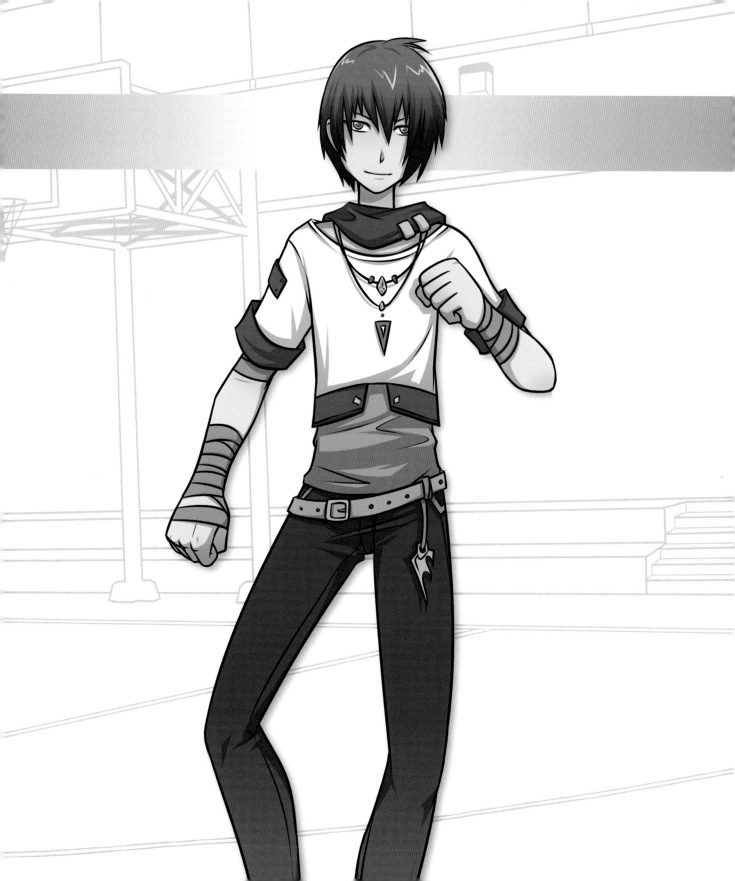

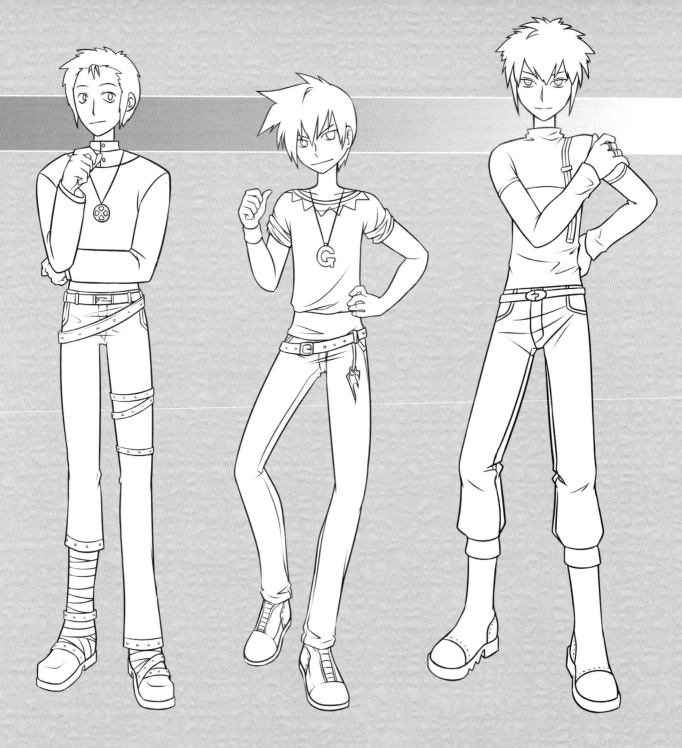

Head: *Male 007*
Upper Body: *Casual 019*
Lower Body: *Punk 007*

Head: *Male 001*
Upper Body: *Casual 009*
Lower Body: *Casual 010*

Head: *Androgynous 013*
Upper Body: *Punk 010*
Lower Body: *Casual 012*

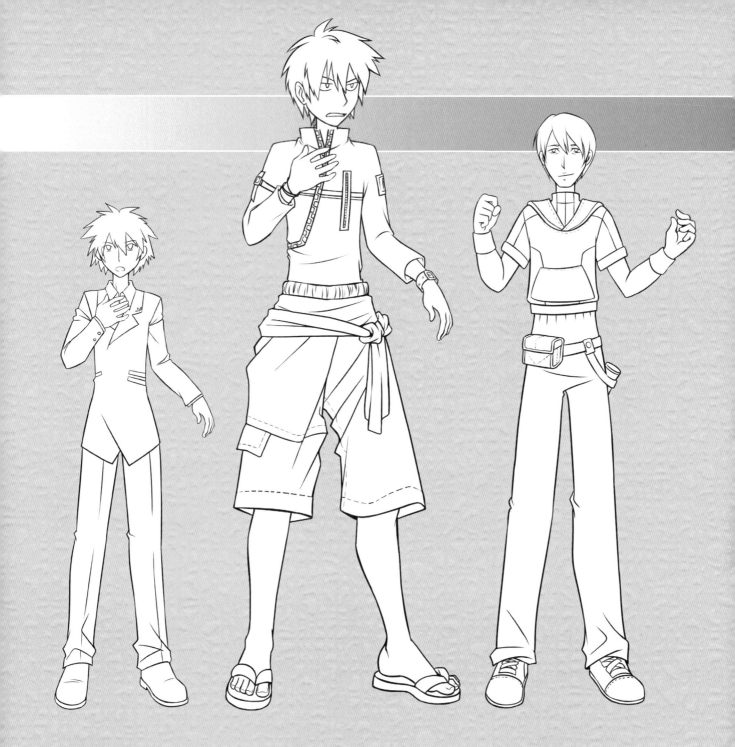

Head: *Male 021*
Upper Body: *Formal 003*
Lower Body: *Work 001*

Head: *Male 003*
Upper Body: *Punk 007*
Lower Body: *Casual 002*

Head: *Male 025*
Upper Body: *Casual 016*
Lower Body: *Casual 016*

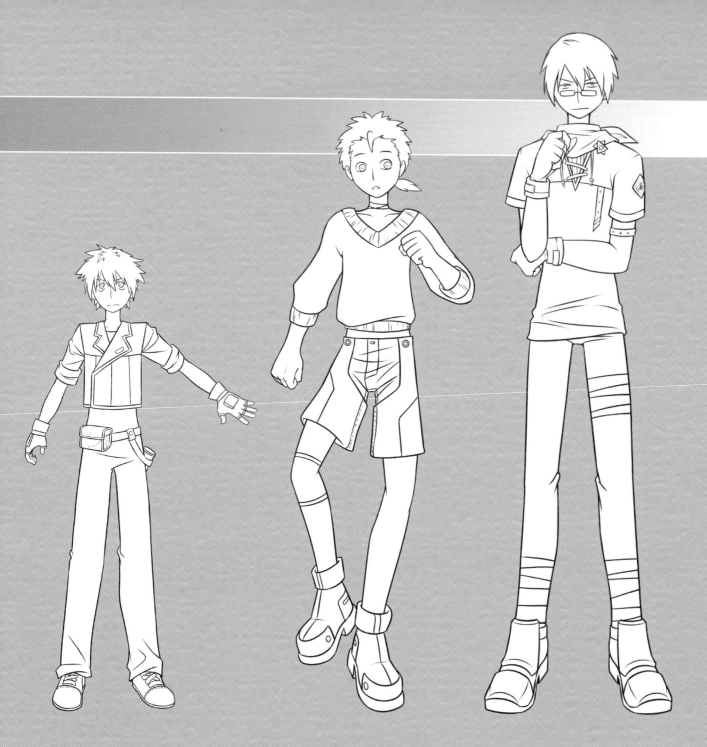

Head: *Male 011*
Upper Body: *Punk 014*
Lower Body: *Casual 016*

Head: *Male 009*
Upper Body: *Casual 008*
Lower Body: *Punk 011*

Head: *Male 013*
Upper Body: *Punk 008*
Lower Body: *Punk 010*

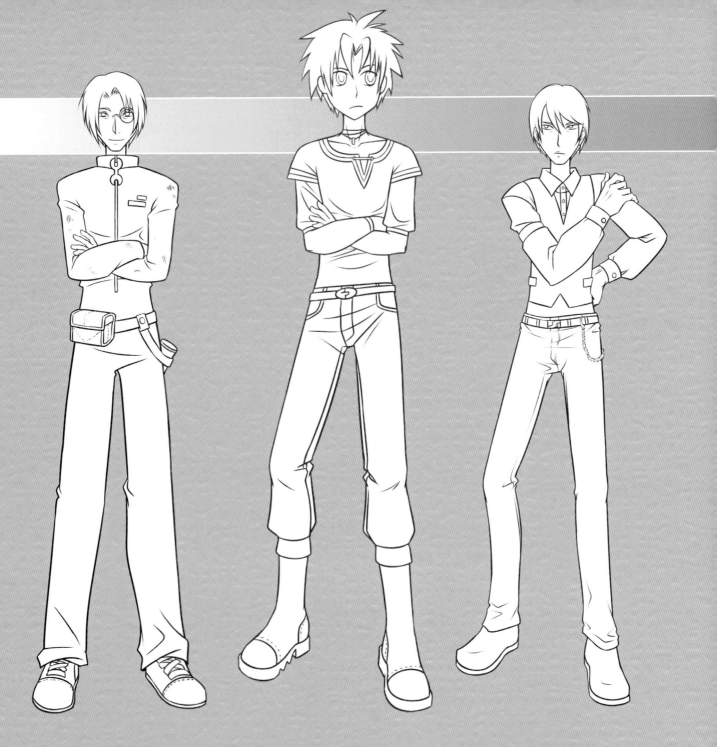

Head: *Male 022*
Upper Body: *Casual 020*
Lower Body: *Casual 016*

Head: *Male 009*
Upper Body: *Casual 015*
Lower Body: *Casual 012*

Head: *Male 026*
Upper Body: *Formal 003*
Lower Body: *Casual 009*

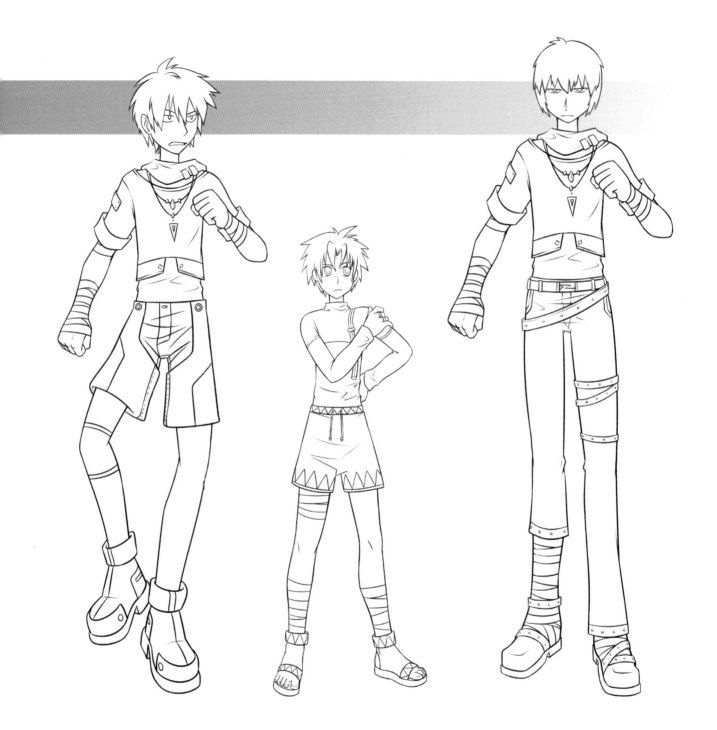

Head: *Male 003*
Upper Body: *Punk 009*
Lower Body: *Punk 011*

Head: *Male 004*
Upper Body: *Punk 010*
Lower Body: *Casual 005*

Head: *Male 015*
Upper Body: *Punk 009*
Lower Body: *Punk 007*

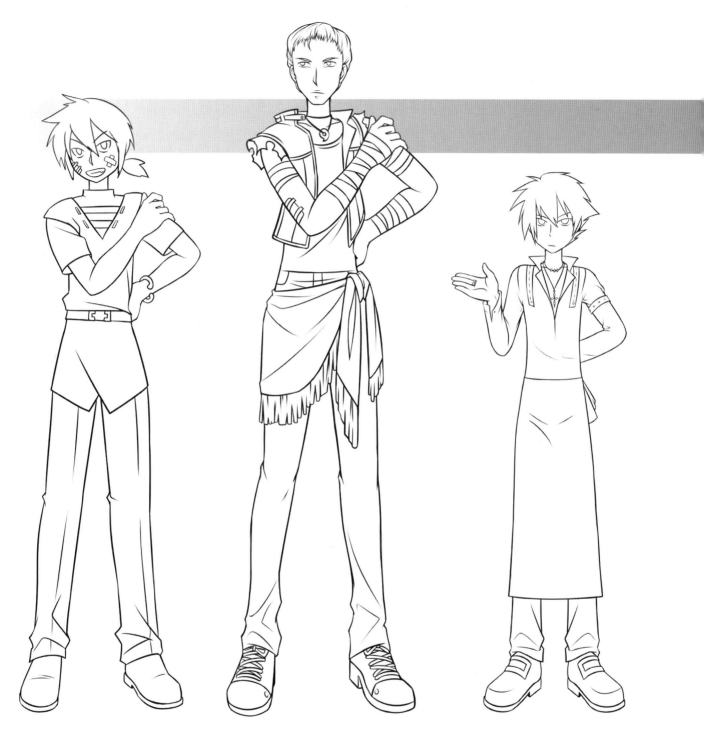

Head: *Male 016*
Upper Body: *Casual 006*
Lower Body: *Work 001*

Head: *Male 024*
Upper Body: *Punk 014*
Lower Body: *Casual 007*

Head: *Male 002*
Upper Body: *Goth 003*
Lower Body: *Work 002*

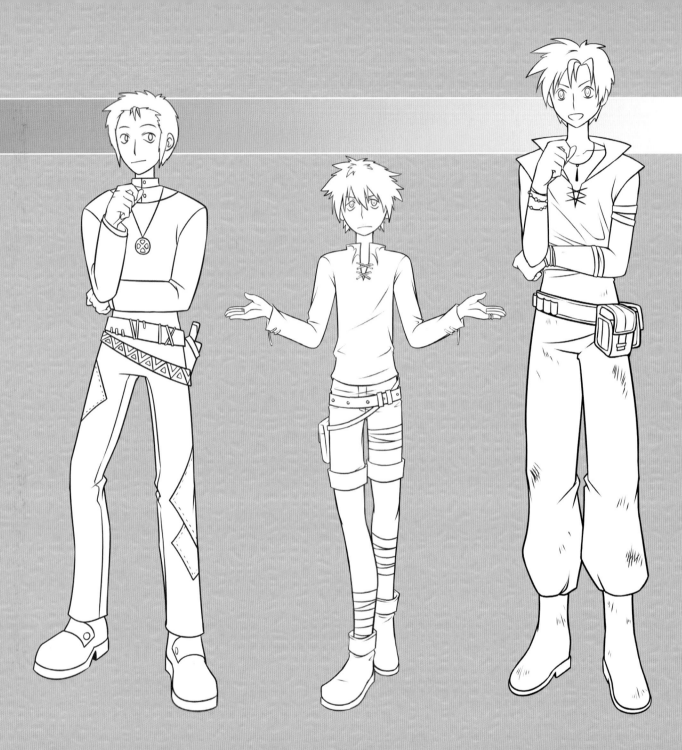

Head: *Male 007*
Upper Body: *Casual 019*
Lower Body: *Action 004*

Head: *Male 011*
Upper Body: *Goth 004*
Lower Body: *Punk 008*

Head: *Male 012*
Upper Body: *Punk 003*
Lower Body: *Action 014*

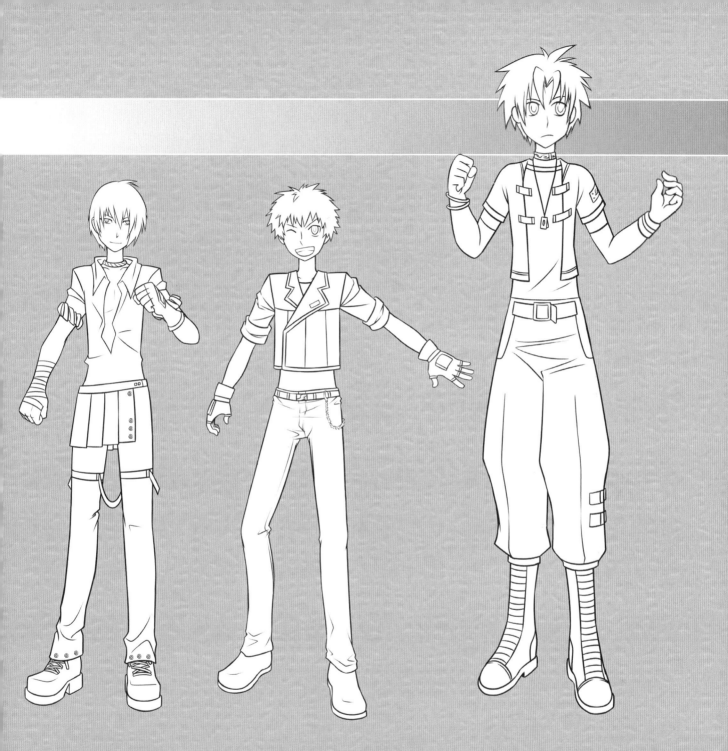

Head: *Male 010*
Upper Body: *Punk 015*
Lower Body: *Goth 008*

Head: *Androgynous 007*
Upper Body: *Punk 013*
Lower Body: *Casual 009*

Head: *Male 004*
Upper Body: *Punk 011*
Lower Body: *Punk 004*

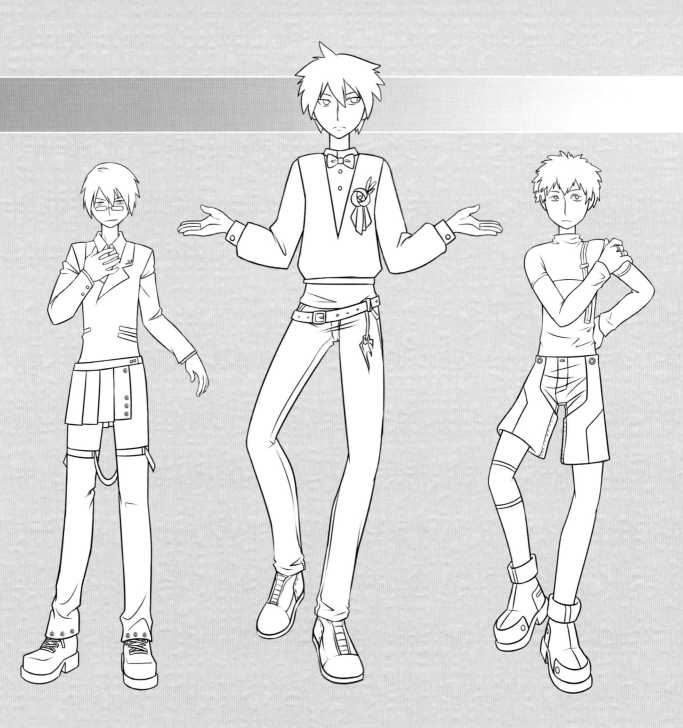

Head: *Male 013*
Upper Body: *Formal 003*
Lower Body: *Goth 008*

Head: *Male 005*
Upper Body: *Goth 001*
Lower Body: *Casual 010*

Head: *Male 006*
Upper Body: *Punk 010*
Lower Body: *Punk 011*

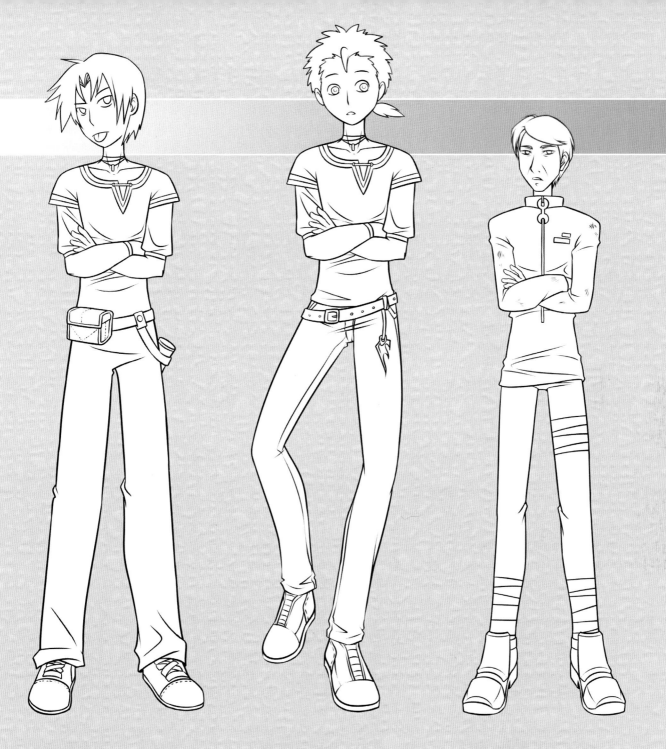

Head: *Male 020*
Upper Body: *Casual 015*
Lower Body: *Casual 016*

Head: *Male 009*
Upper Body: *Casual 015*
Lower Body: *Casual 010*

Head: *Male 023*
Upper Body: *Casual 020*
Lower Body: *Punk 010*

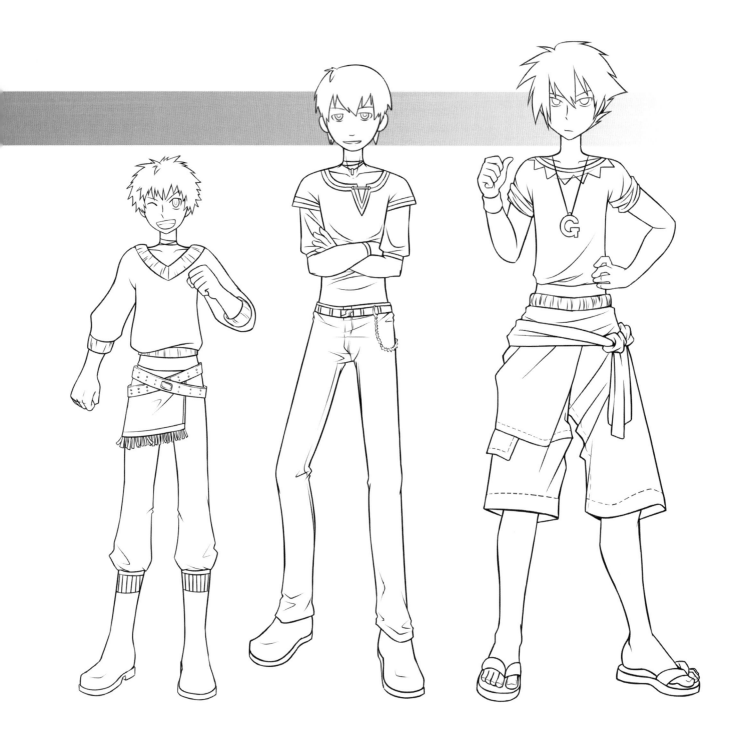

Head: *Androgynous 007*
Upper Body: *Casual 008*
Lower Body: *Goth 004*

Head: *Male 019*
Upper Body: *Casual 015*
Lower Body: *Casual 009*

Head: *Male 002*
Upper Body: *Casual 009*
Lower Body: *Casual 002*

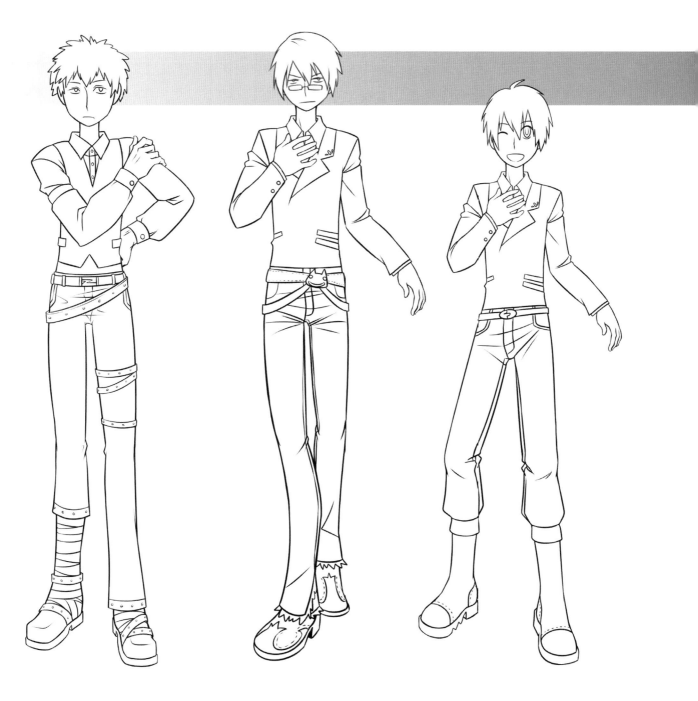

Head: *Male 006*
Upper Body: *Formal 005*
Lower Body: *Punk 007*

Head: *Male 013*
Upper Body: *Formal 003*
Lower Body: *Goth 009*

Head: *Male 018*
Upper Body: *Formal 003*
Lower Body: *Casual 012*

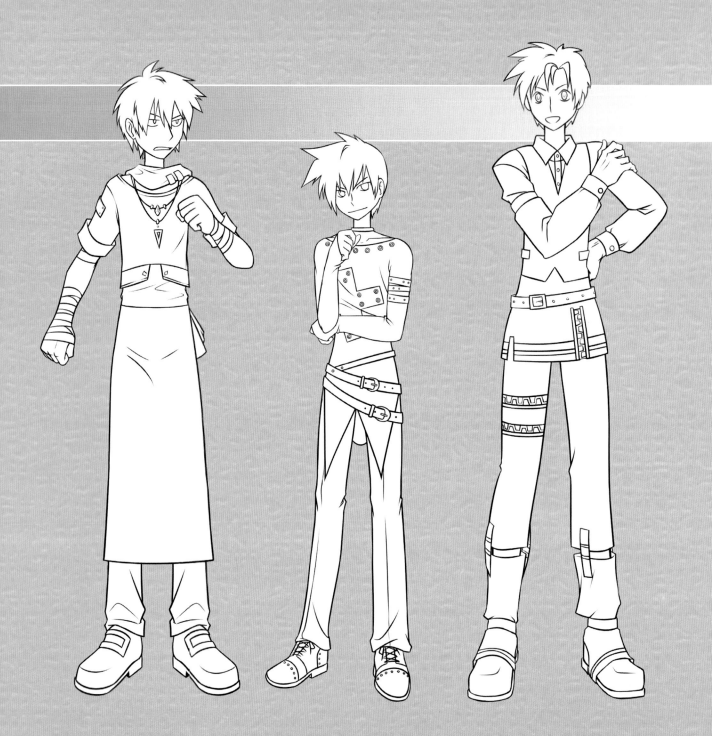

Head: *Male 003*
Upper Body: *Punk 009*
Lower Body: *Work 002*

Head: *Male 001*
Upper Body: *Glam 003*
Lower Body: *Punk 013*

Head: *Male 012*
Upper Body: *Formal 005*
Lower Body: *Goth 003*

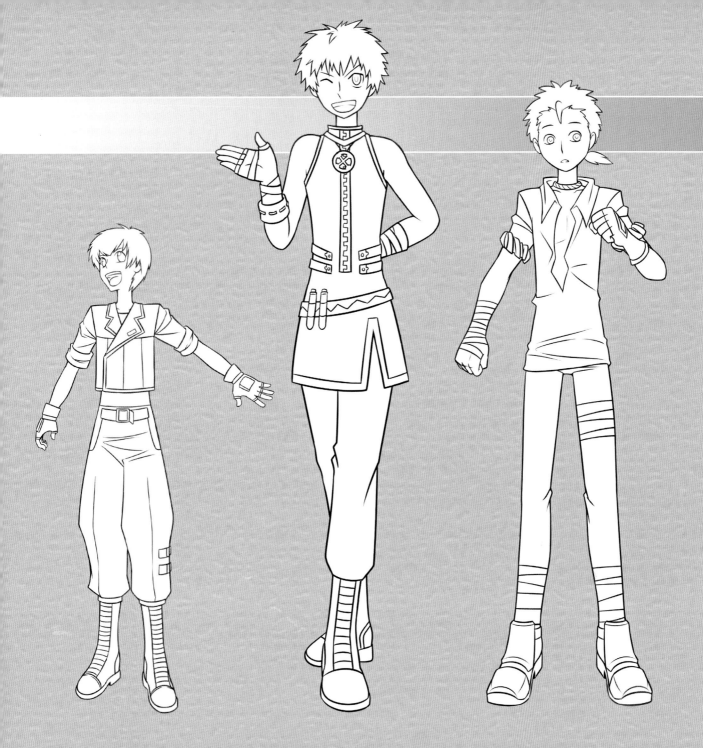

Head: *Androgynous 008*
Upper Body: *Punk 013*
Lower Body: *Punk 004*

Head: *Androgynous 007*
Upper Body: *Punk 001*
Lower Body: *Action 013*

Head: *Male 009*
Upper Body: *Punk 015*
Lower Body: *Punk 010*

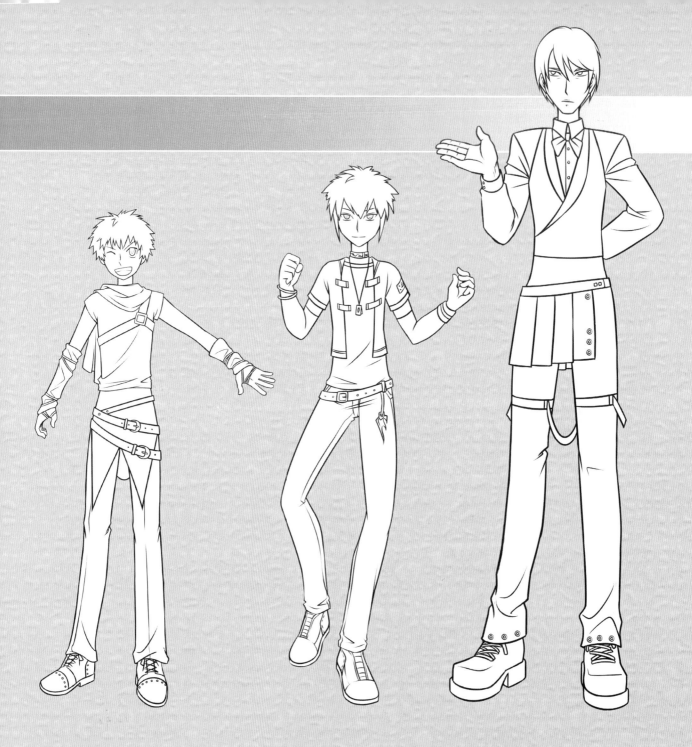

Head: *Androgynous 007*
Upper Body: *Action 003*
Lower Body: *Punk 013*

Head: *Androgynous 013*
Upper Body: *Punk 012*
Lower Body: *Casual 010*

Head: *Male 026*
Upper Body: *Formal 004*
Lower Body: *Goth 008*

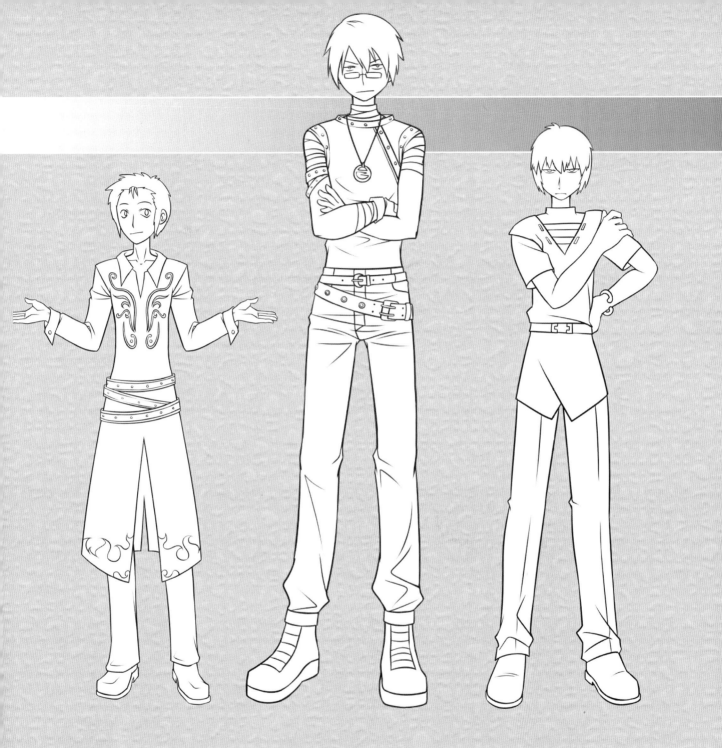

Head: *Male 007*
Upper Body: *Glam 008*
Lower Body: *Fantasy 004*

Head: *Male 013*
Upper Body: *Punk 008*
Lower Body: *Casual 006*

Head: *Male 015*
Upper Body: *Casual 006*
Lower Body: *Work 001*

action and adventure

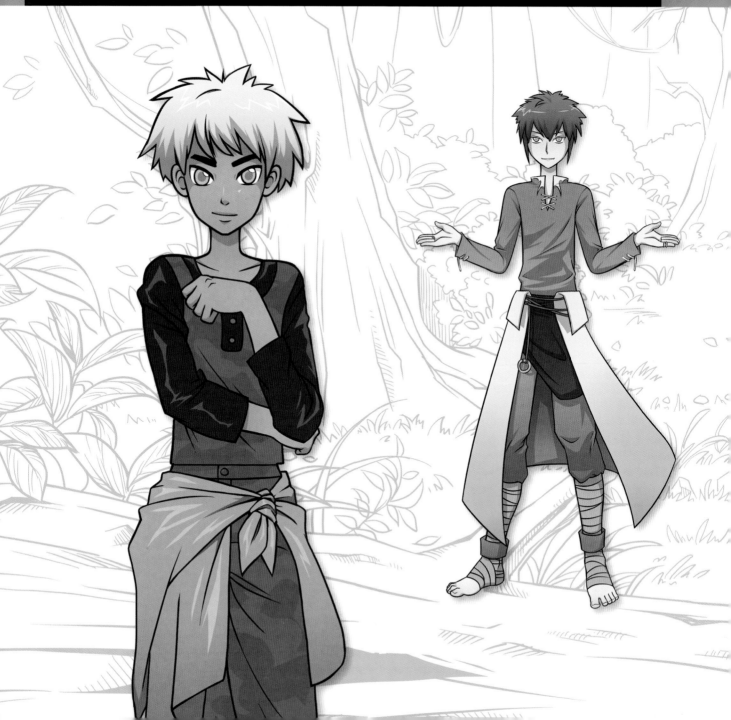

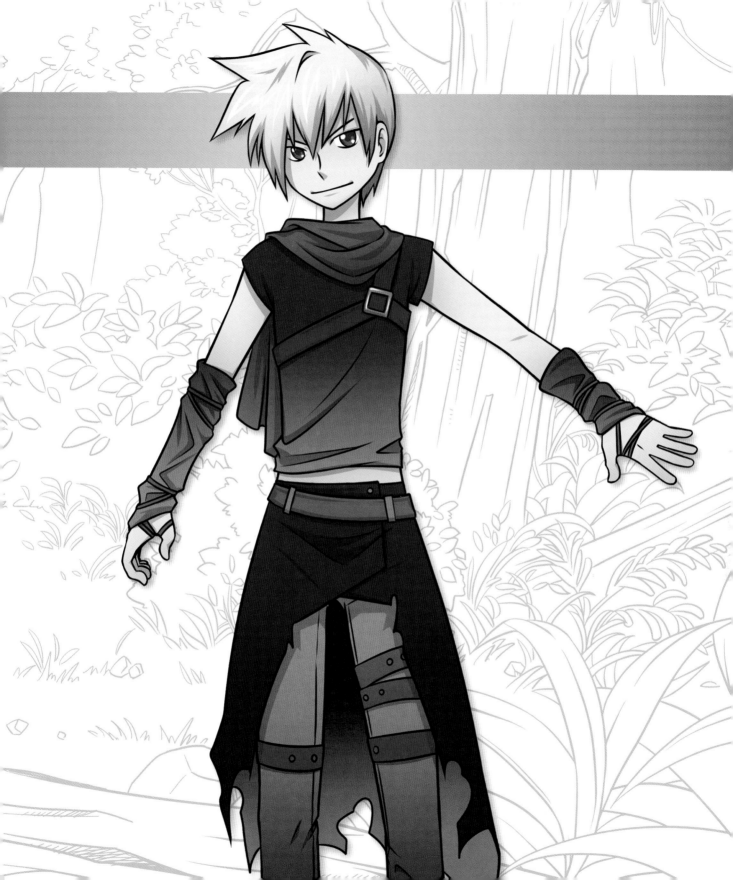

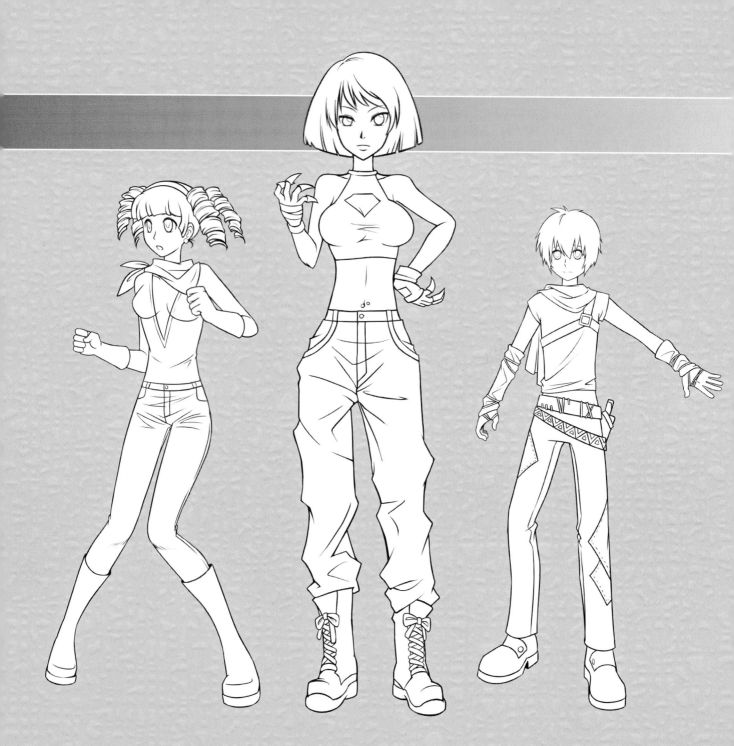

Head: *Female 013*
Upper Body: *Action 002*
Lower Body: *Action 003*

Head: *Female 005*
Upper Body: *Action 001*
Lower Body: *Action 001*

Head: *Androgynous 011*
Upper Body: *Action 003*
Lower Body: *Action 004*

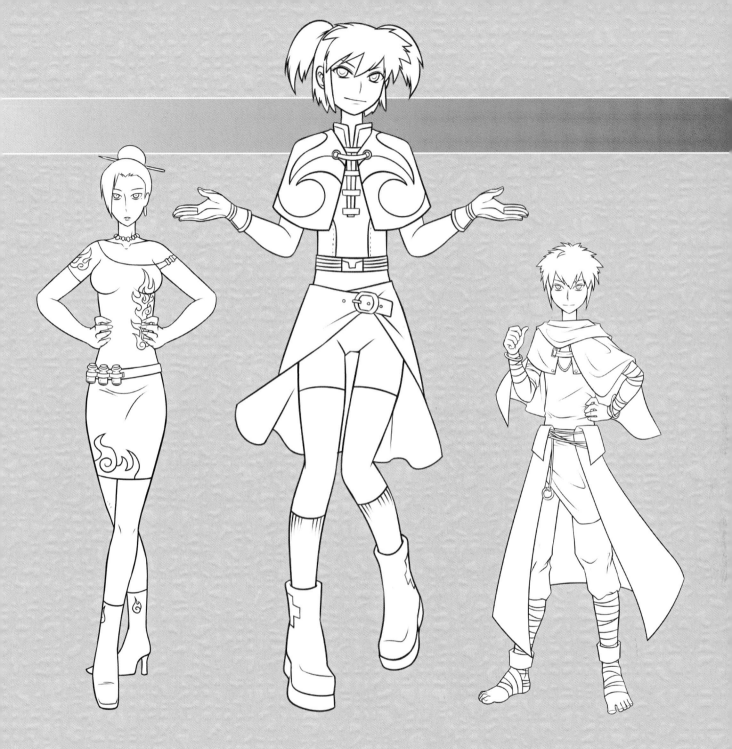

Head: *Female 038*
Upper Body: *Punk 016*
Lower Body: *Action 015*

Head: *Female 014*
Upper Body: *Action 006*
Lower Body: *Action 007*

Head: *Androgynous 013*
Upper Body: *Action 004*
Lower Body: *Action 008*

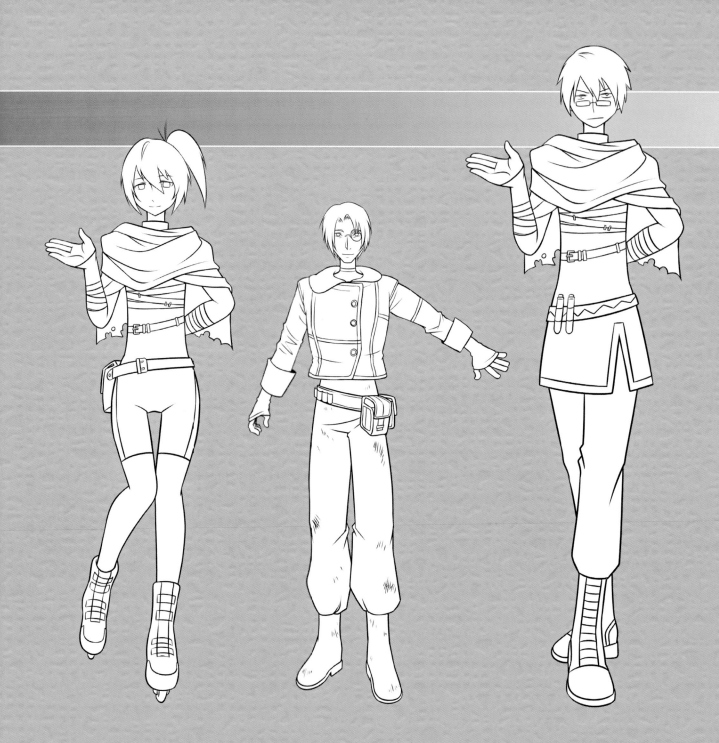

Head: *Female 024*
Upper Body: *Action 005*
Lower Body: *Action 011*

Head: *Male 022*
Upper Body: *Casual 003*
Lower Body: *Action 014*

Head: *Male 013*
Upper Body: *Action 005*
Lower Body: *Action 013*

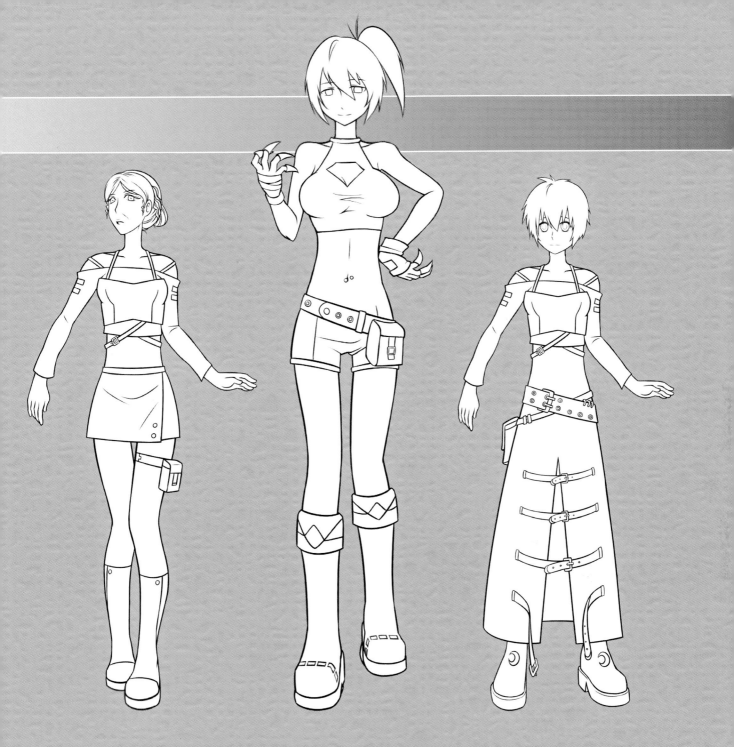

Head: *Female 034*
Upper Body: *Punk 004*
Lower Body: *Action 006*

Head: *Female 024*
Upper Body: *Action 001*
Lower Body: *Action 009*

Head: *Androgynous 011*
Upper Body: *Punk 004*
Lower Body: *Goth 010*

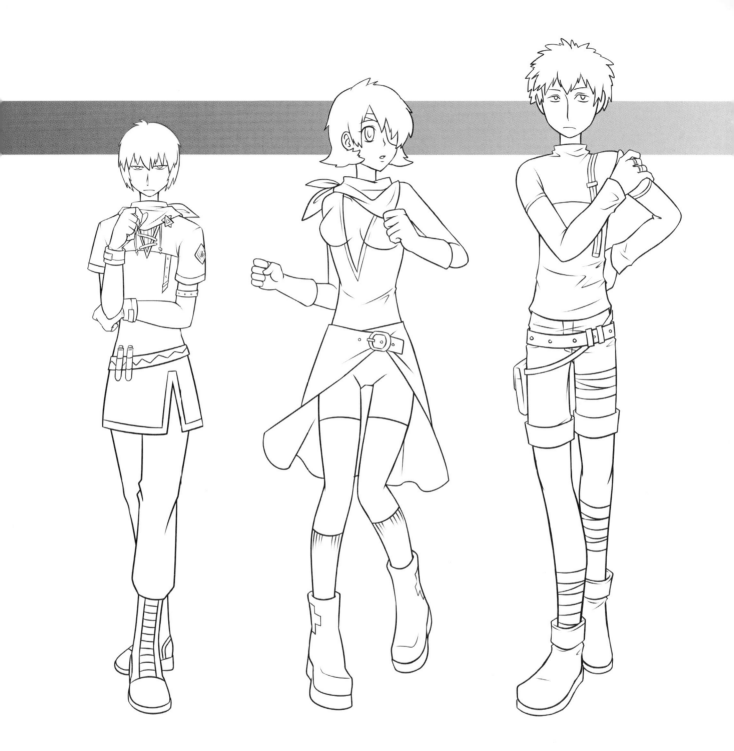

Head: *Male 015*
Upper Body: *Punk 007*
Lower Body: *Action 013*

Head: *Female 006*
Upper Body: *Action 002*
Lower Body: *Action 007*

Head: *Male 006*
Upper Body: *Punk 010*
Lower Body: *Punk 008*

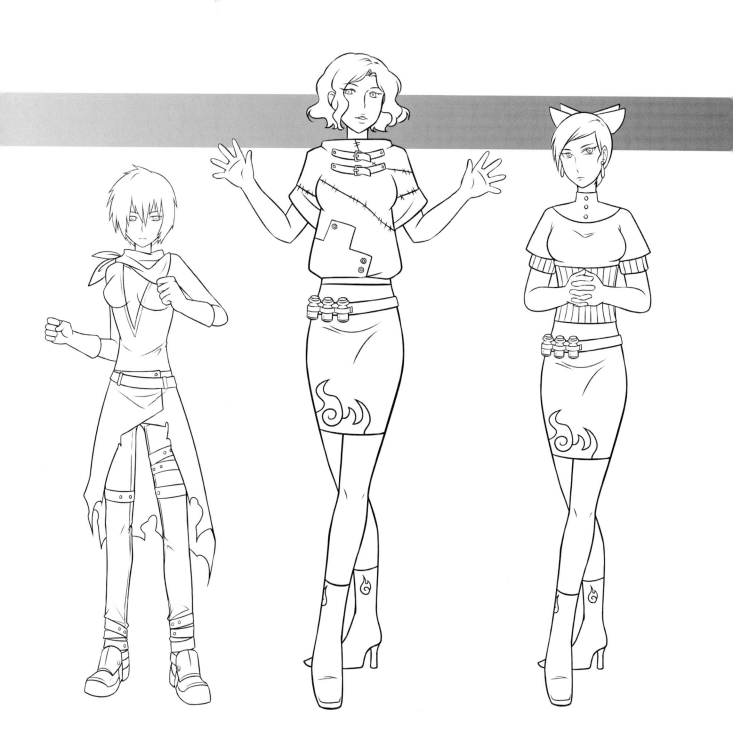

Head: *Androgynous 010*
Upper Body: *Action 002*
Lower Body: *Action 005*

Head: *Female 036*
Upper Body: *Goth 007*
Lower Body: *Action 015*

Head: *Female 037*
Upper Body: *Feminine 006*
Lower Body: *Action 015*

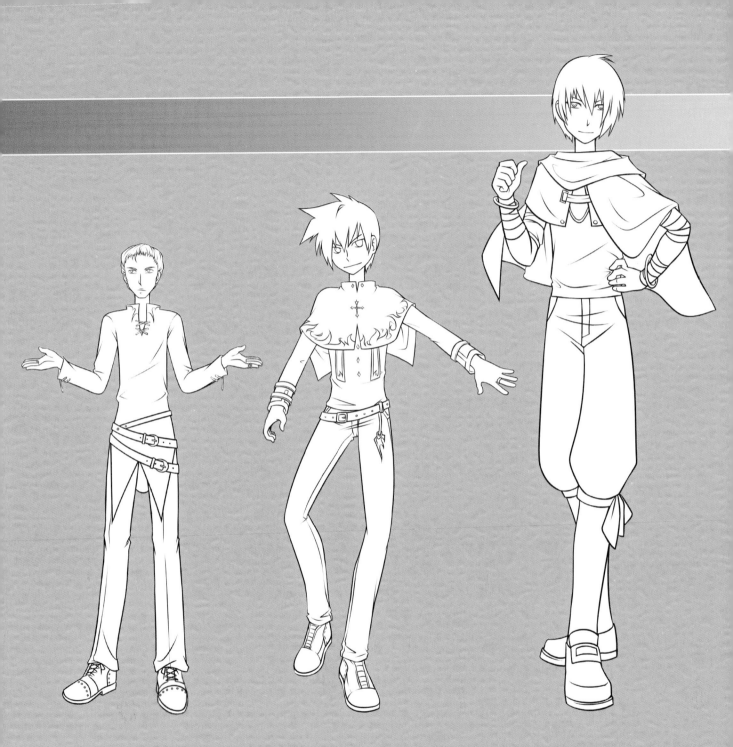

Head: *Male 024*
Upper Body: *Goth 004* —
Lower Body: *Punk 013*

Head: *Male 001*
Upper Body: *Goth 002*
Lower Body: *Casual 010*

Head: *Male 010*
Upper Body: *Action 004*
Lower Body: *Goth 002*

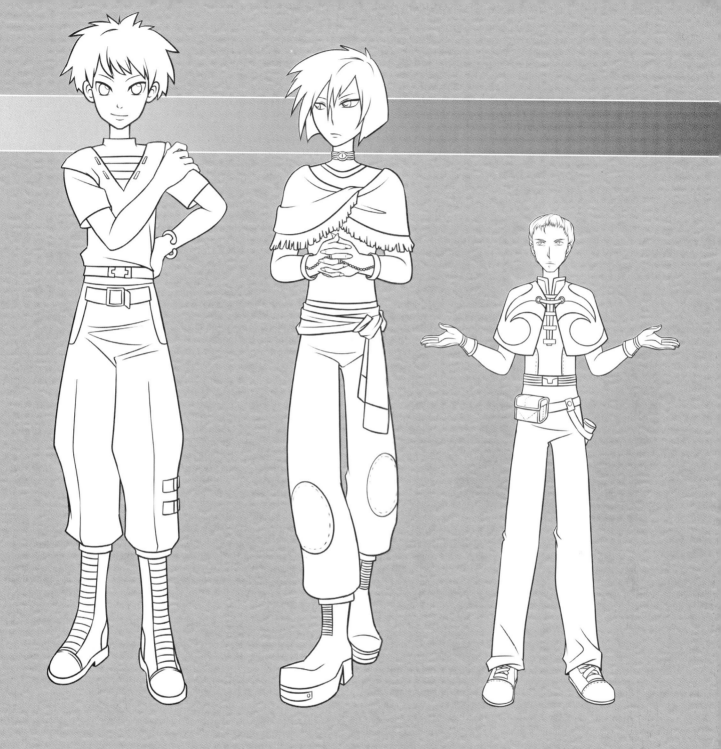

Head: *Androgynous 001*
Upper Body: *Casual 006*
Lower Body: *Punk 004*

Head: *Androgynous 018*
Upper Body: *Glam 010*
Lower Body: *Punk 003*

Head: *Male 024*
Upper Body: *Action 006*
Lower Body: *Casual 016*

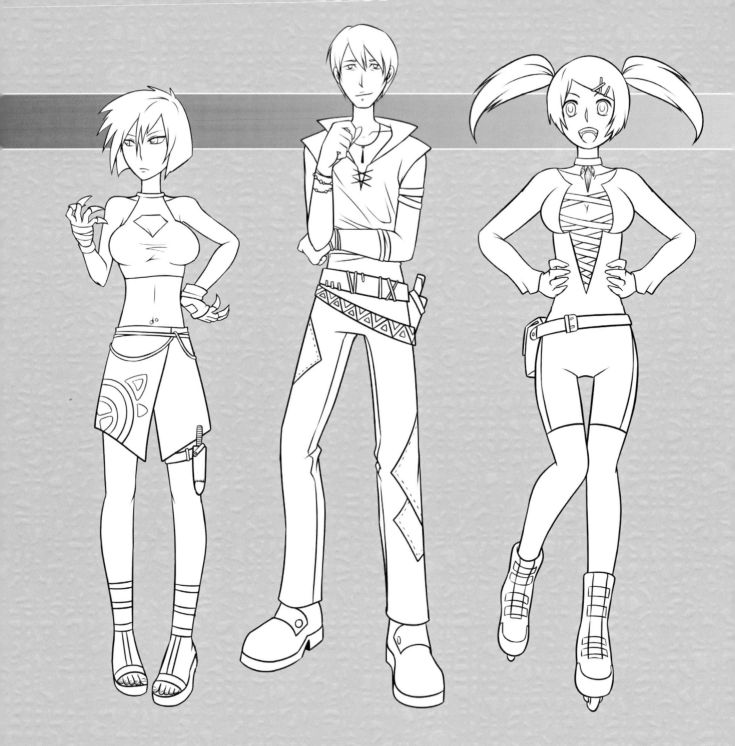

Head: *Androgynous 018*
Upper Body: *Action 001*
Lower Body: *Action 010*

Head: *Male 025*
Upper Body: *Punk 003*
Lower Body: *Action 004*

Head: *Female 015*
Upper Body: *Glam 002*
Lower Body: *Action 011*

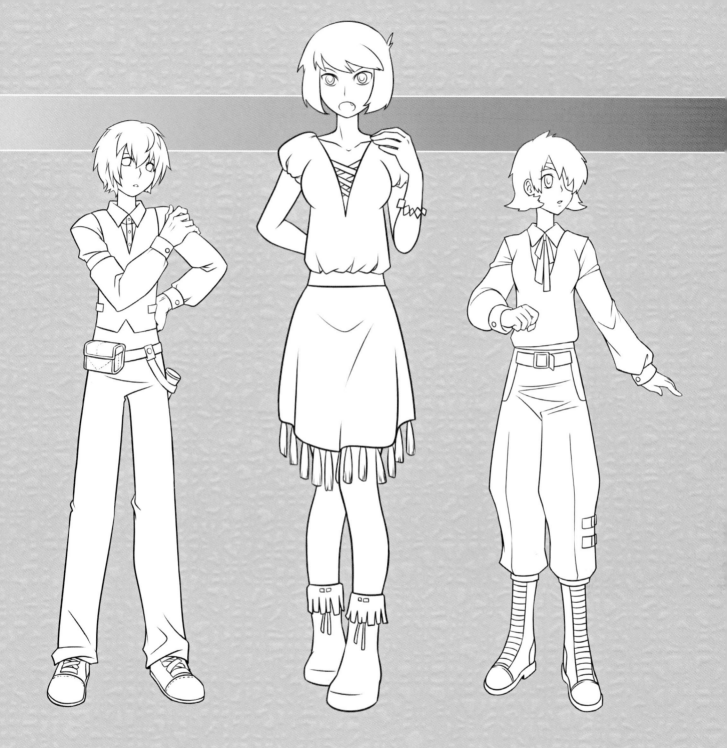

Head: *Androgynous 004*
Upper Body: *Formal 005*
Lower Body: *Casual 016*

Head: *Female 026*
Upper Body: *Feminine 021*
Lower Body: *Casual 014*

Head: *Female 006*
Upper Body: *Formal 001*
Lower Body: *Punk 004*

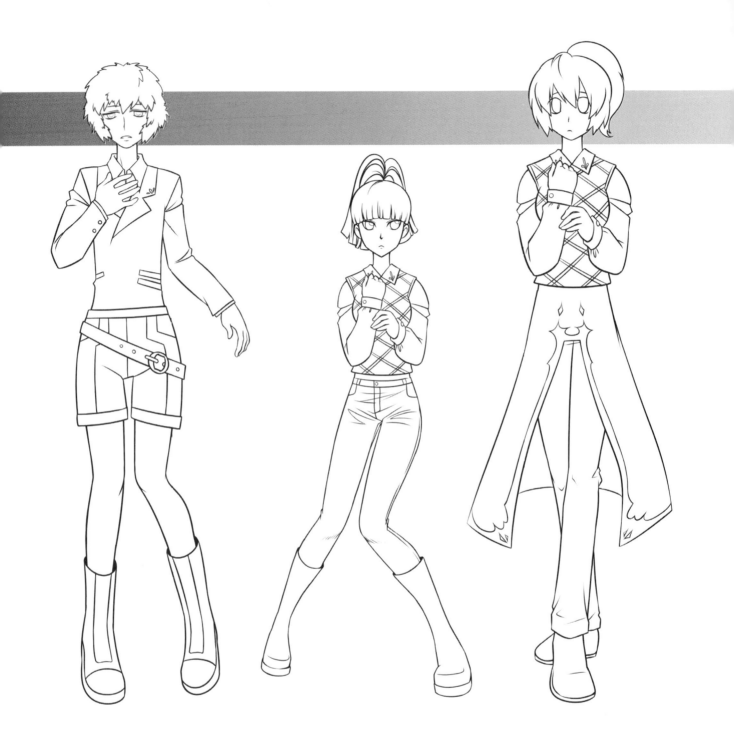

Head: *Androgynous 012*
Upper Body: *Formal 003*
Lower Body: *Casual 008*

Head: *Female 002*
Upper Body: *Formal 002*
Lower Body: *Action 003*

Head: *Female 010*
Upper Body: *Formal 002*
Lower Body: *Goth 005*

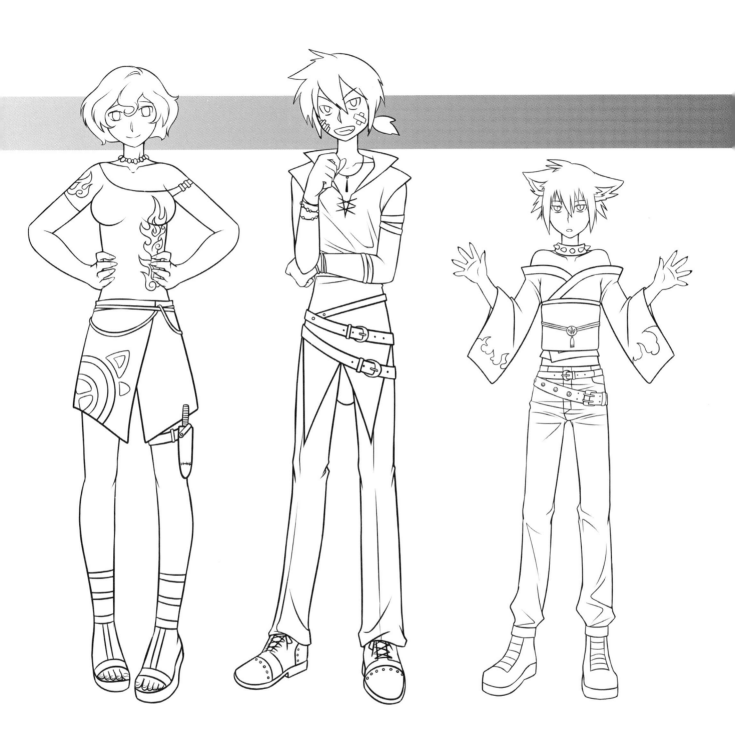

Head: *Female 023*
Upper Body: *Punk 016*
Lower Body: *Action 010*

Head: *Male 016*
Upper Body: *Punk 003*
Lower Body: *Punk 013*

Head: *Fantasy 006*
Upper Body: *Feminine 005*
Lower Body: *Casual 006*

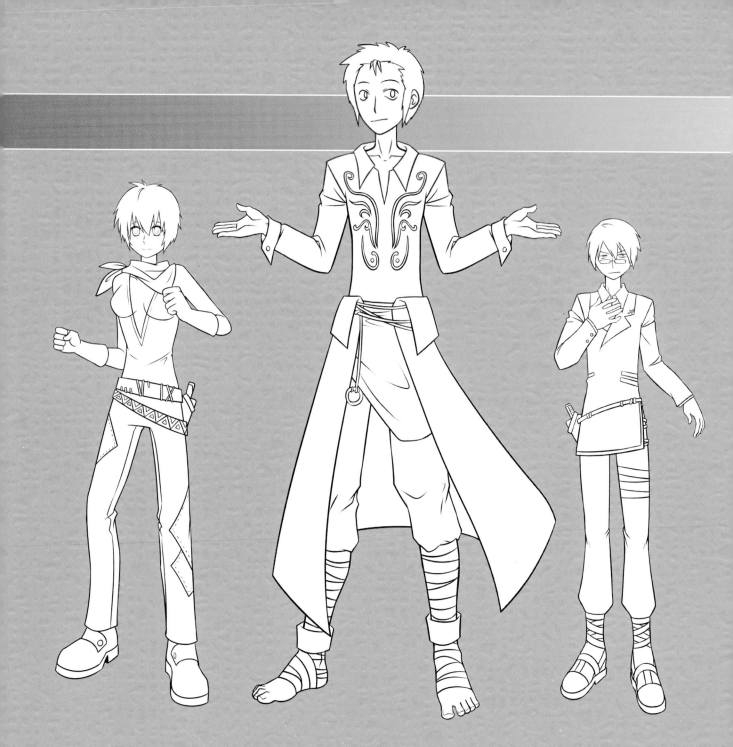

Head: *Androgynous 011*
Upper Body: *Action 002*
Lower Body: *Action 004*

Head: *Male 007*
Upper Body: *Glam 008*
Lower Body: *Action 008*

Head: *Male 013*
Upper Body: *Formal 003*
Lower Body: *Action 012*

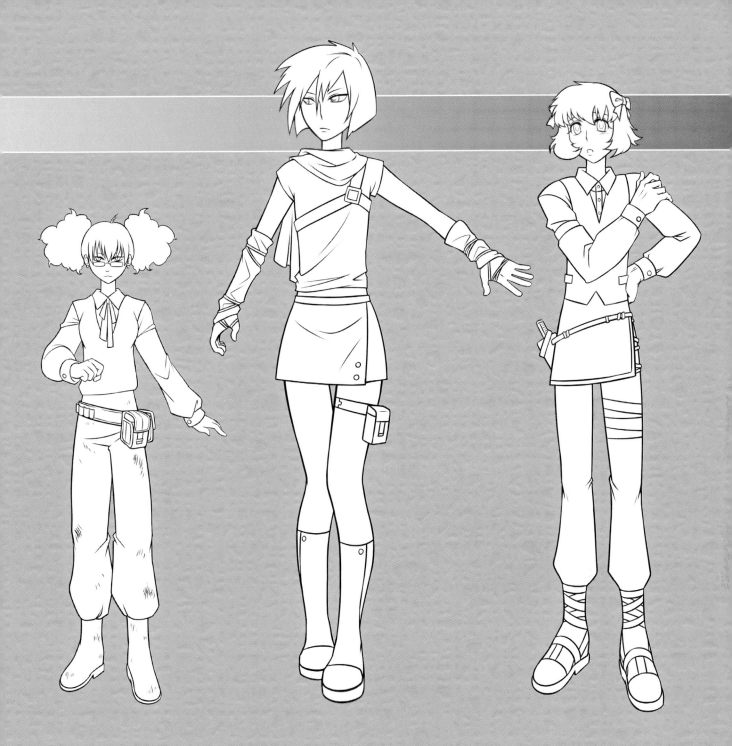

Head: *Female 019*
Upper Body: *Formal 001*
Lower Body: *Action 014*

Head: *Androgynous 018*
Upper Body: *Action 003*
Lower Body: *Action 006*

Head: *Female 021*
Upper Body: *Formal 005*
Lower Body: *Action 012*

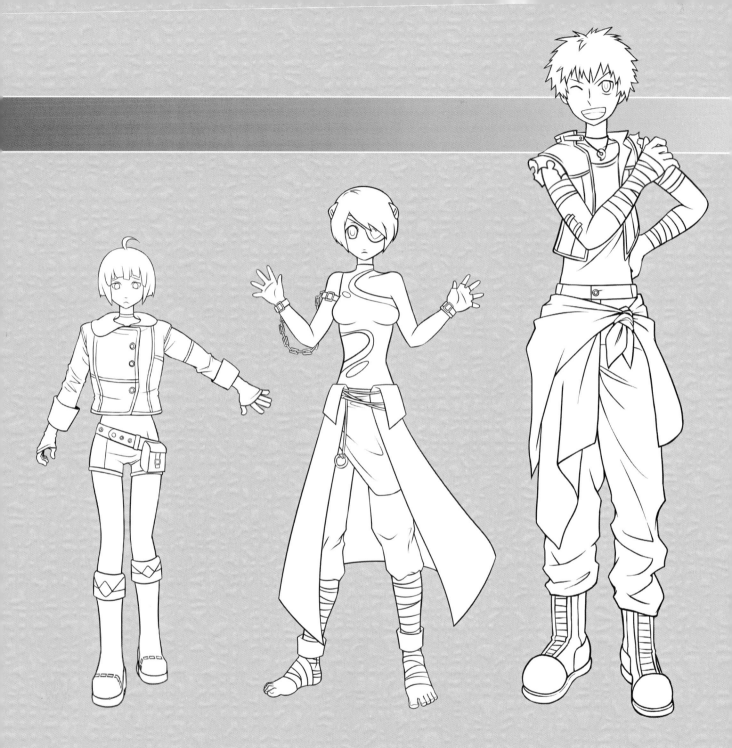

Head: *Androgynous 017*
Upper Body: *Casual 003*
Lower Body: *Action 009*

Head: *Fantasy 003*
Upper Body: *Punk 012*
Lower Body: *Action 008*

Head: *Androgynous 007*
Upper Body: *Punk 014*
Lower Body: *Action 002*

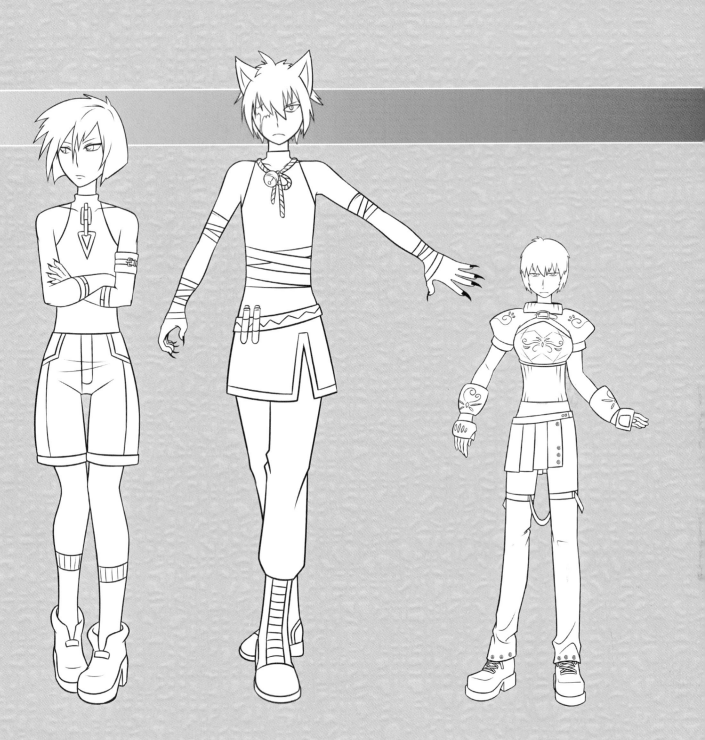

Head: *Androgynous 018*
Upper Body: *Goth 009*
Lower Body: *Casual 011*

Head: *Fantasy 007*
Upper Body: *Fantasy 004*
Lower Body: *Action 013*

Head: *Male 015*
Upper Body: *Fantasy 003*
Lower Body: *Goth 008*

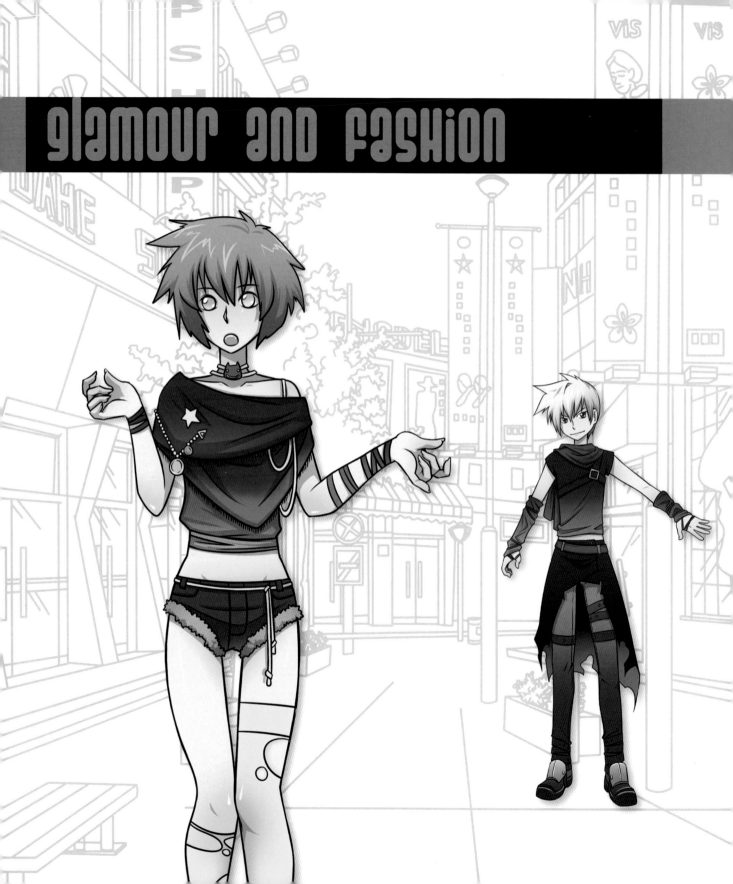

glamour and fashion

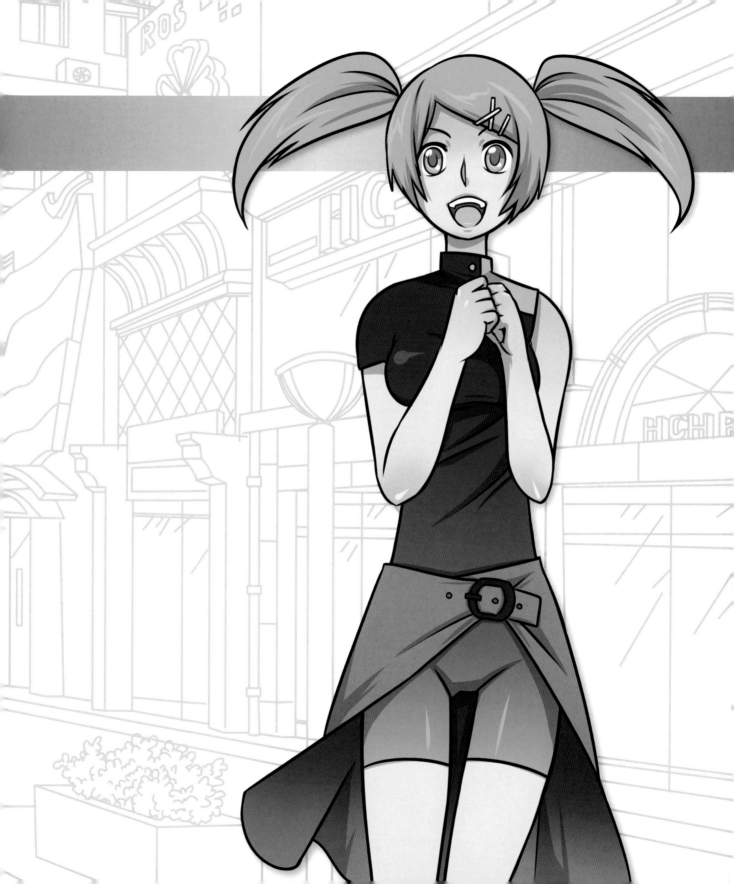

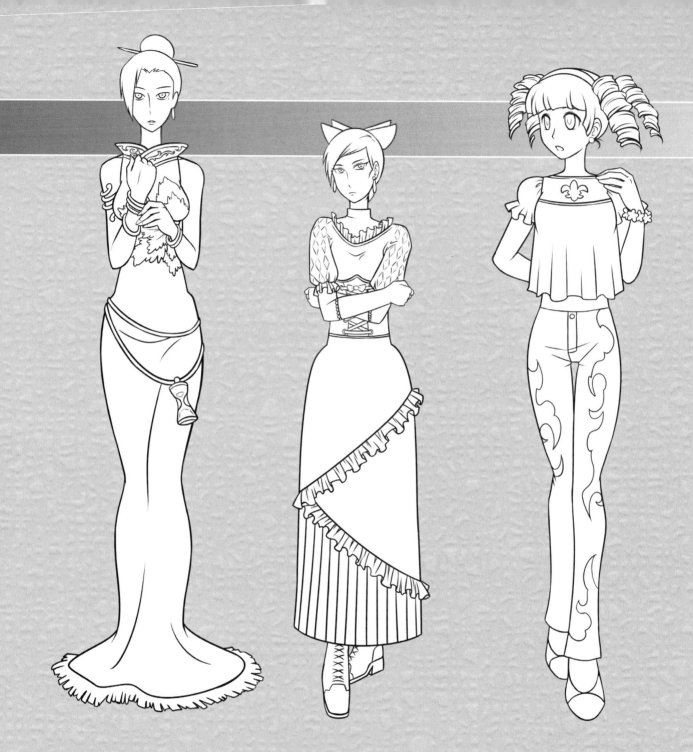

Head: *Female 038*
Upper Body: *Glam 011*
Lower Body: *Glam 011*

Head: *Female 037*
Upper Body: *Glam 009*
Lower Body: *Feminine 014*

Head: *Female 013*
Upper Body: *Feminine 010*
Lower Body: *Glam 001*

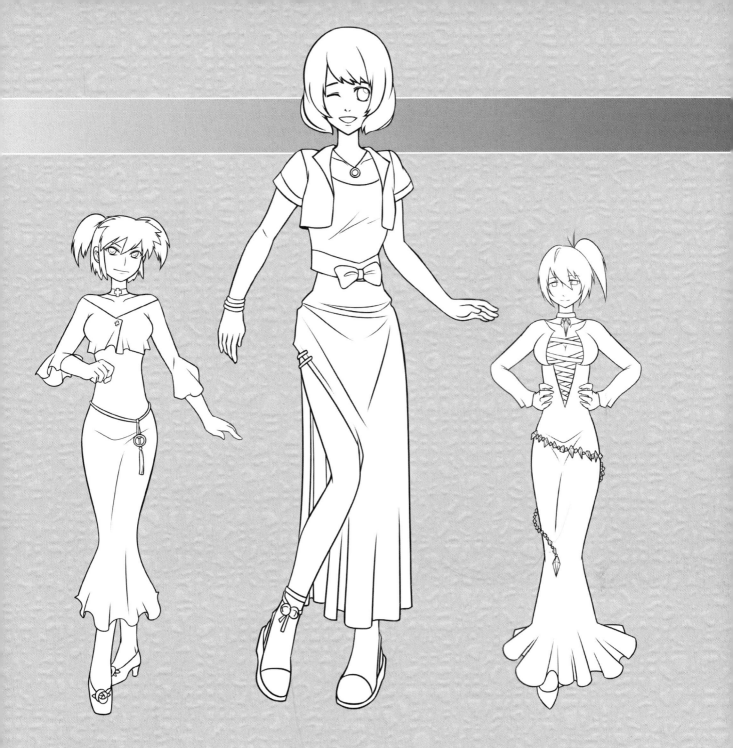

Head: *Female 014*
Upper Body: *Glam 001*
Lower Body: *Glam 004*

Head: *Female 001*
Upper Body: *Feminine 003*
Lower Body: *Glam 003*

Head: *Female 024*
Upper Body: *Glam 002*
Lower Body: *Glam 006*

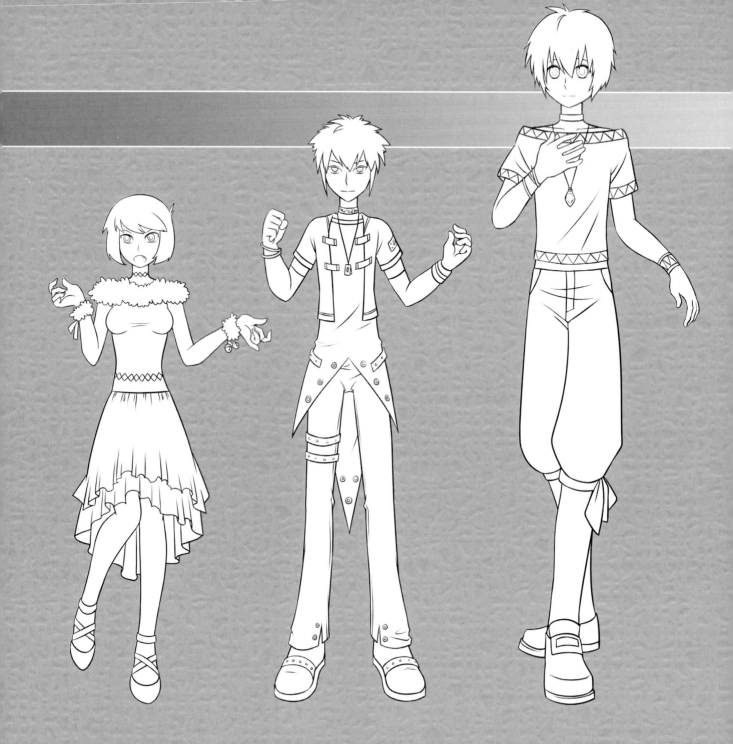

Head: *Female 026*
Upper Body: *Glam 006*
Lower Body: *Glam 008*

Head: *Androgynous 013*
Upper Body: *Punk 011*
Lower Body: *Glam 005*

Head: *Androgynous 011*
Upper Body: *Casual 010*
Lower Body: *Goth 002*

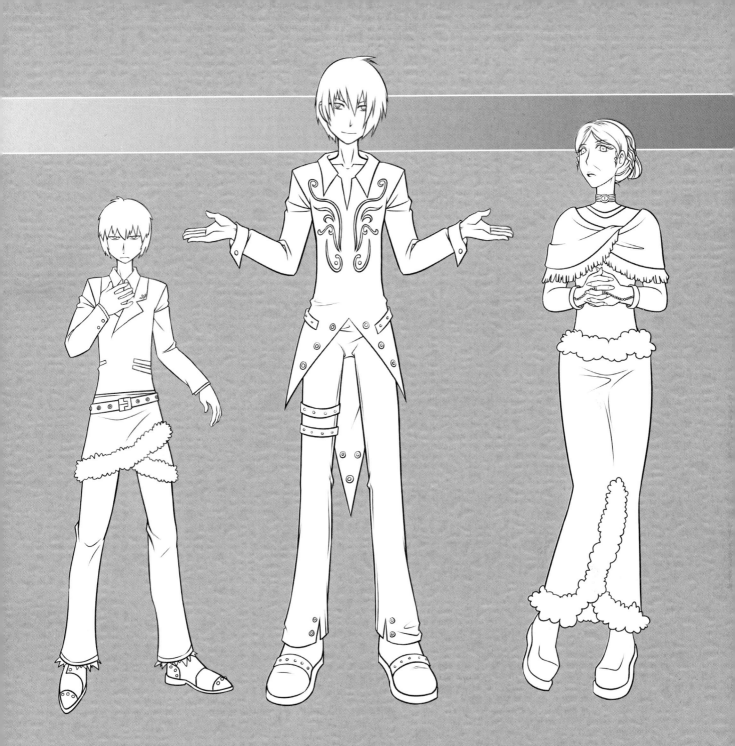

Head: *Male 015*
Upper Body: *Formal 003*
Lower Body: *Glam 007*

Head: *Male 010*
Upper Body: *Glam 008*
Lower Body: *Glam 005*

Head: *Female 034*
Upper Body: *Glam 010*
Lower Body: *Glam 009*

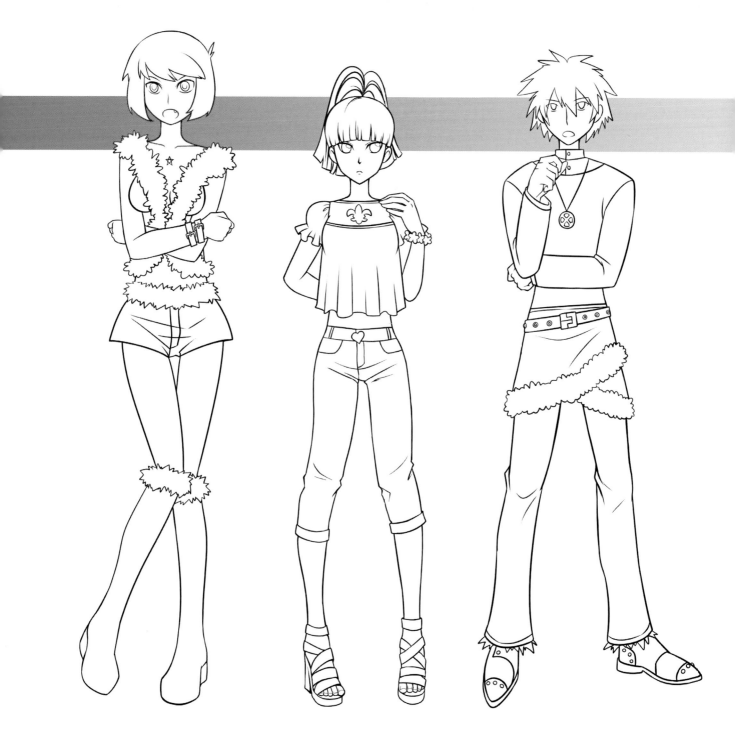

Head: *Female 026*
Upper Body: *Glam 012*
Lower Body: *Glam 002*

Head: *Female 002*
Upper Body: *Feminine 010*
Lower Body: *Feminine 003*

Head: *Male 021*
Upper Body: *Casual 019*
Lower Body: *Glam 007*

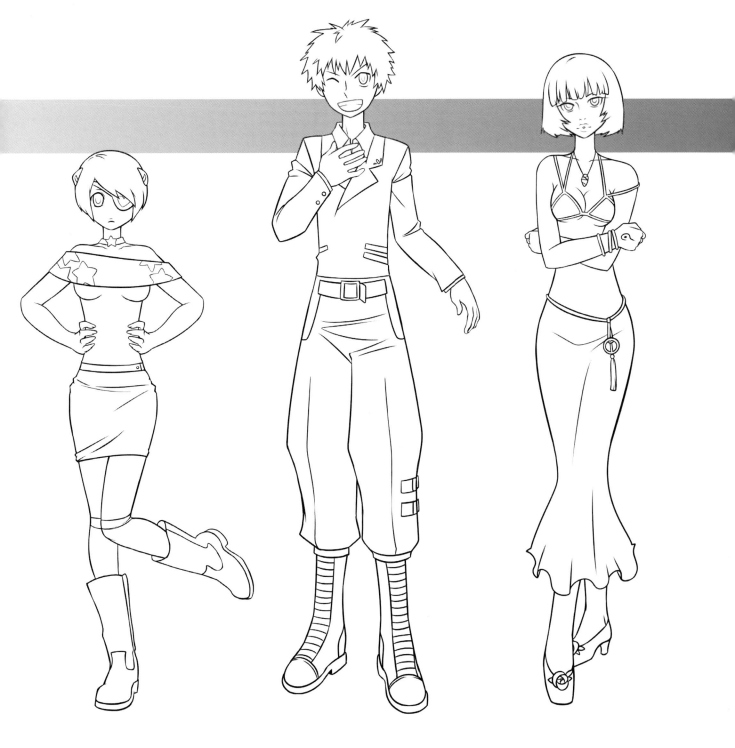

Head: *Fantasy 003*
Upper Body: *Glam 007*
Lower Body: *Feminine 002*

Head: *Androgynous 007*
Upper Body: *Formal 003*
Lower Body: *Punk 004*

Head: *Female 018*
Upper Body: *Feminine 015*
Lower Body: *Glam 004*

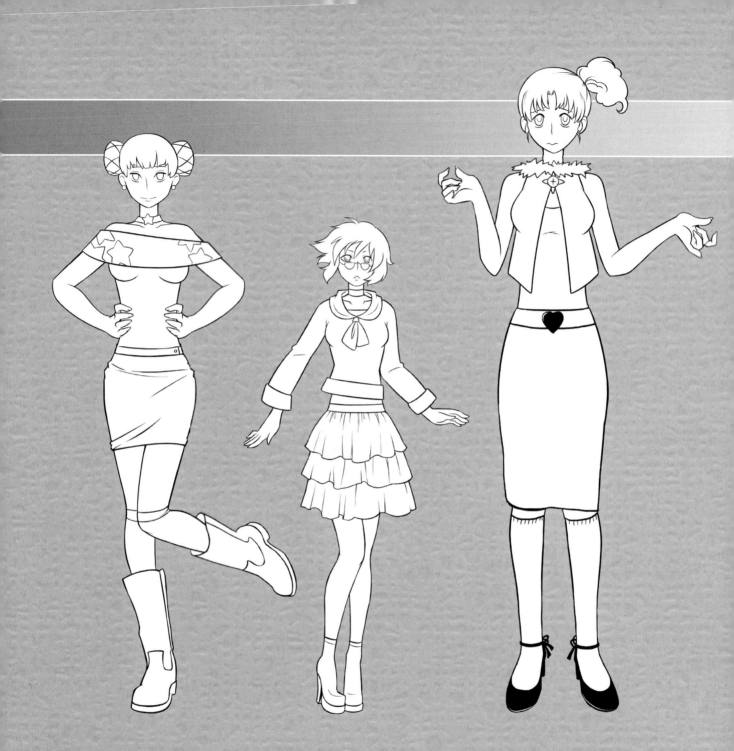

Head: *Female 030*
Upper Body: *Glam 007*
Lower Body: *Feminine 002*

Head: *Female 025*
Upper Body: *Feminine 020*
Lower Body: *Feminine 004*

Head: *Female 028*
Upper Body: *Feminine 009*
Lower Body: *Feminine 013*

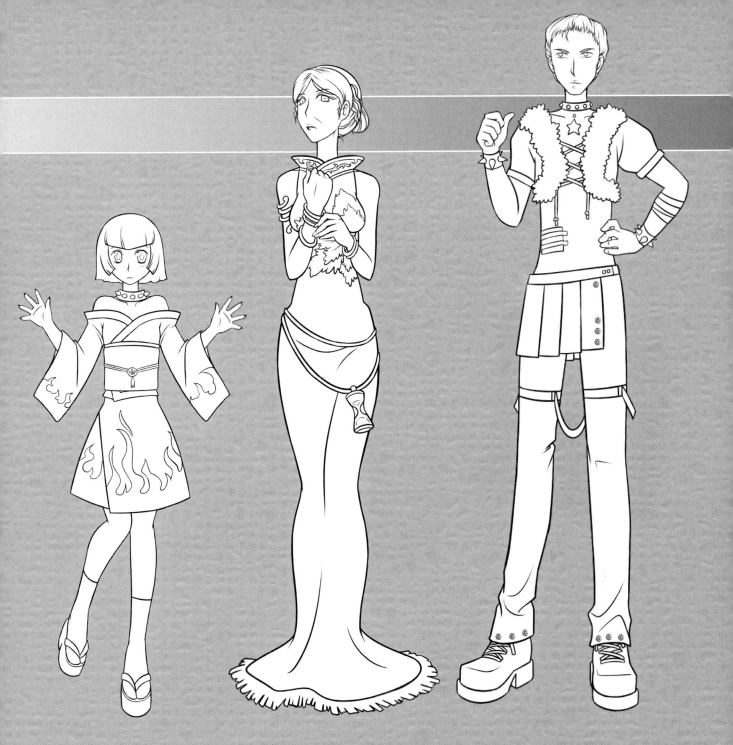

Head: *Female 011*
Upper Body: *Feminine 005*
Lower Body: *Feminine 016*

Head: *Female 034*
Upper Body: *Glam 011*
Lower Body: *Glam 011*

Head: *Male 024*
Upper Body: *Glam 004*
Lower Body: *Goth 008*

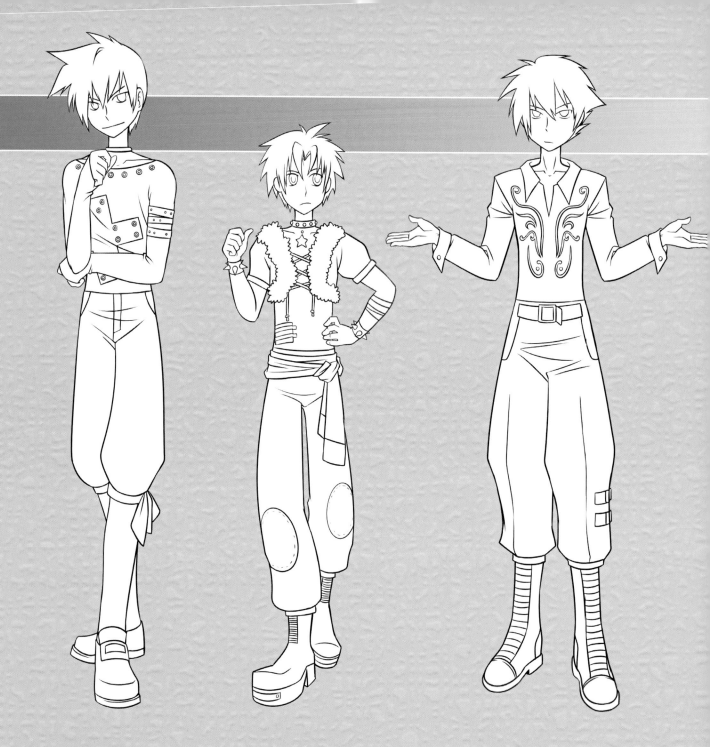

Head: *Male 001*
Upper Body: *Glam 003*
Lower Body: *Goth 002*

Head: *Male 004*
Upper Body: *Glam 004*
Lower Body: *Punk 003*

Head: *Male 002*
Upper Body: *Glam 008*
Lower Body: *Punk 004*

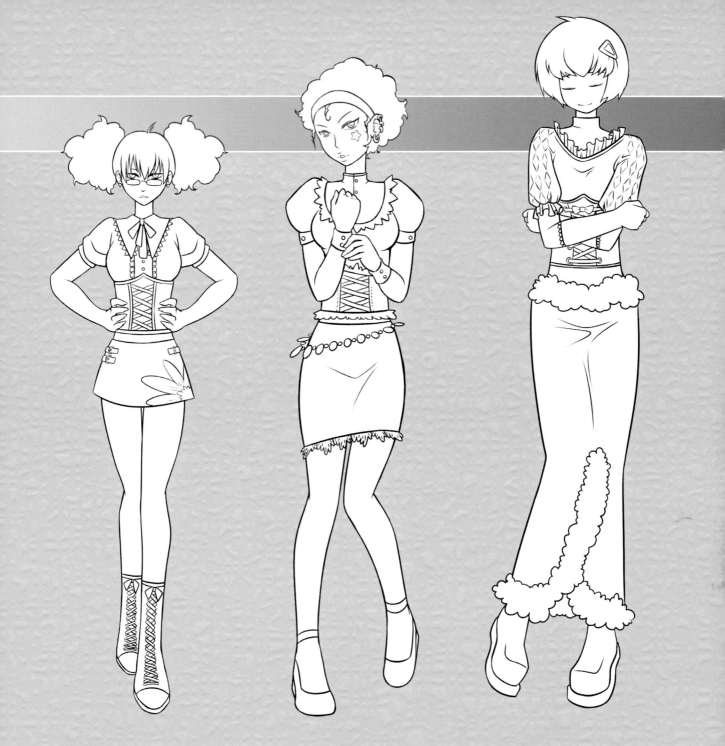

Head: *Female 016*
Upper Body: *Feminine 011*
Lower Body: *Feminine 011*

Head: *Female 032*
Upper Body: *Feminine 012*
Lower Body: *Feminine 012*

Head: *Female 009*
Upper Body: *Glam 009*
Lower Body: *Glam 009*

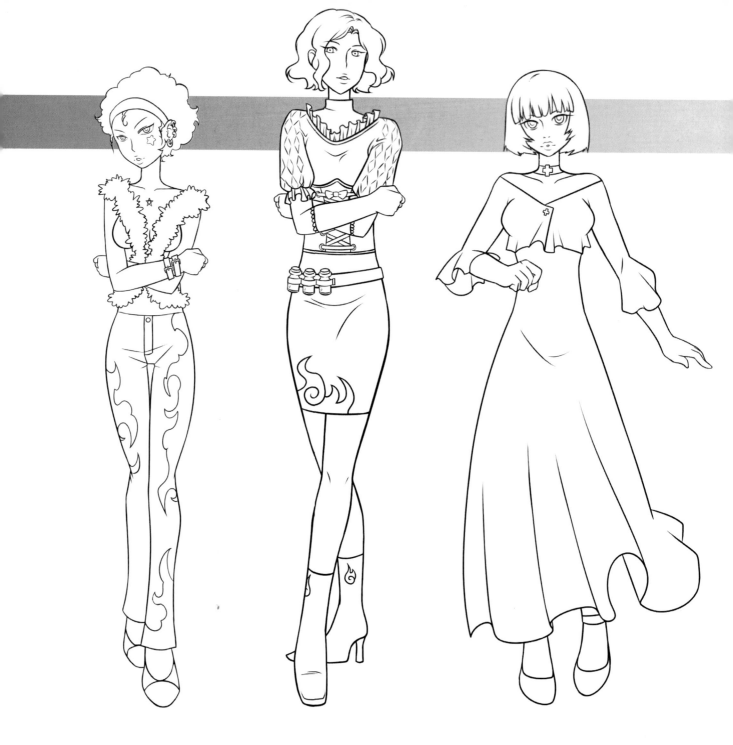

Head: *Female 032*
Upper Body: *Glam 012*
Lower Body: *Glam 001*

Head: *Female 036*
Upper Body: *Glam 009*
Lower Body: *Action 015*

Head: *Female 018*
Upper Body: *Glam 001*
Lower Body: *Feminine 010*

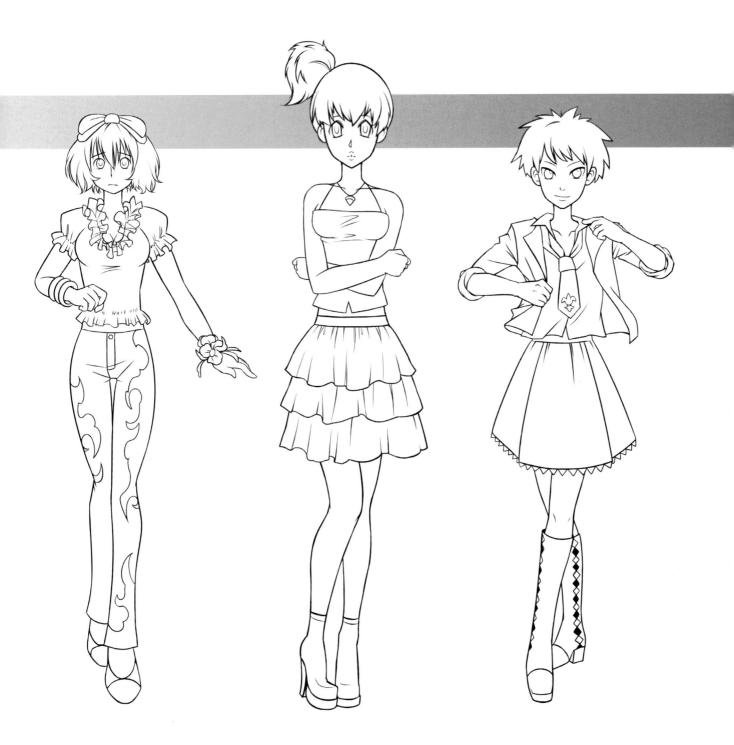

Head: *Female 033*
Upper Body: *Glam 005*
Lower Body: *Glam 001*

Head: *Female 004*
Upper Body: *Feminine 008*
Lower Body: *Feminine 004*

Head: *Androgynous 001*
Upper Body: *Casual 002*
Lower Body: *Feminine 007*

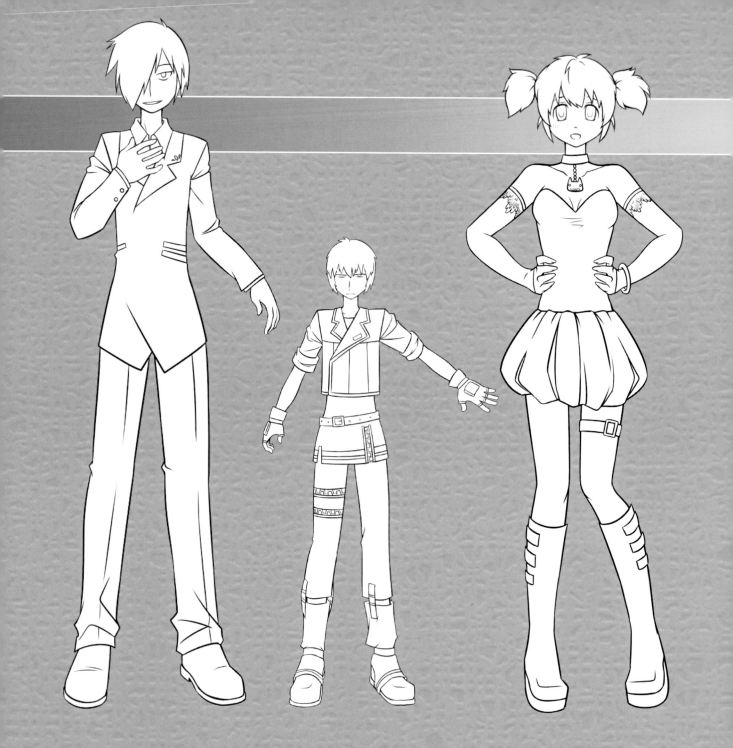

Head: *Androgynous 020*
Upper Body: *Formal 003*
Lower Body: *Work 001*

Head: *Male 015*
Upper Body: *Punk 013*
Lower Body: *Goth 003*

Head: *Female 008*
Upper Body: *Feminine 017*
Lower Body: *Punk 009*

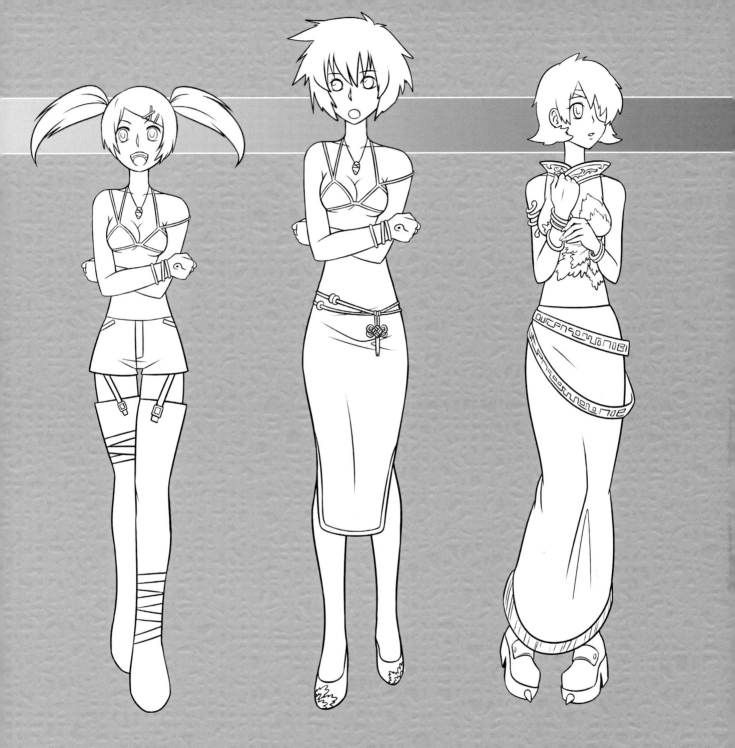

Head: *Female 015*
Upper Body: *Feminine 015*
Lower Body: *Punk 012*

Head: *Female 017*
Upper Body: *Feminine 015*
Lower Body: *Feminine 015*

Head: *Female 006*
Upper Body: *Glam 011*
Lower Body: *Goth 006*

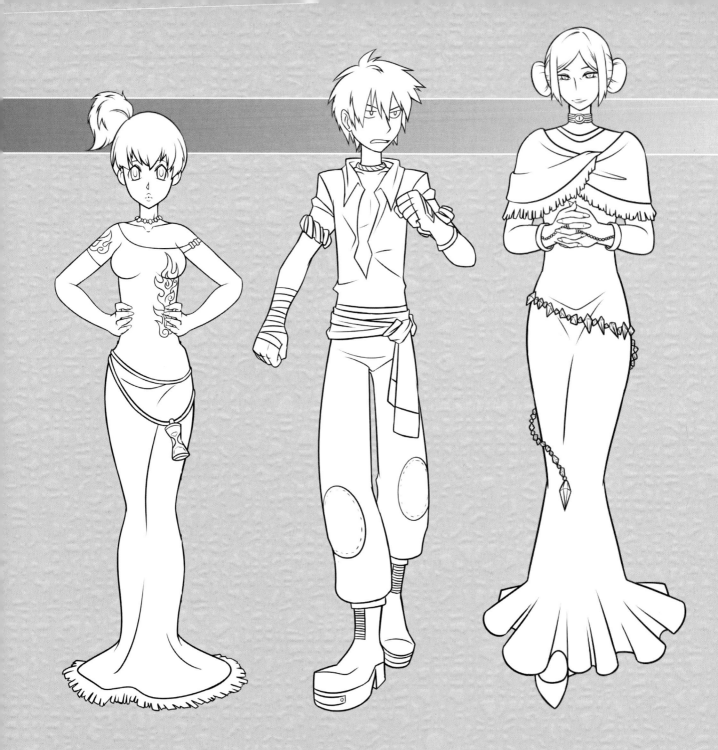

Head: *Female 004*
Upper Body: *Punk 016*
Lower Body: *Glam 011*

Head: *Male 003*
Upper Body: *Punk 015*
Lower Body: *Punk 003*

Head: *Female 037*
Upper Body: *Glam 010*
Lower Body: *Glam 006*

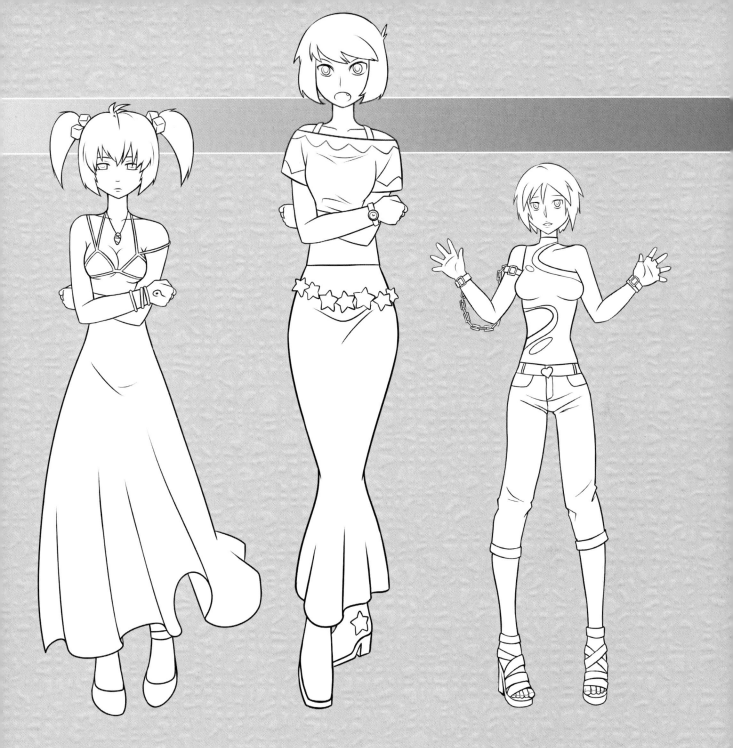

Head: *Female 007*
Upper Body: *Feminine 015*
Lower Body: *Feminine 010*

Head: *Female 026*
Upper Body: *Casual 017*
Lower Body: *Glam 010*

Head: *Androgynous 016*
Upper Body: *Punk 012*
Lower Body: *Feminine 003*

Sci-Fi and Fantasy

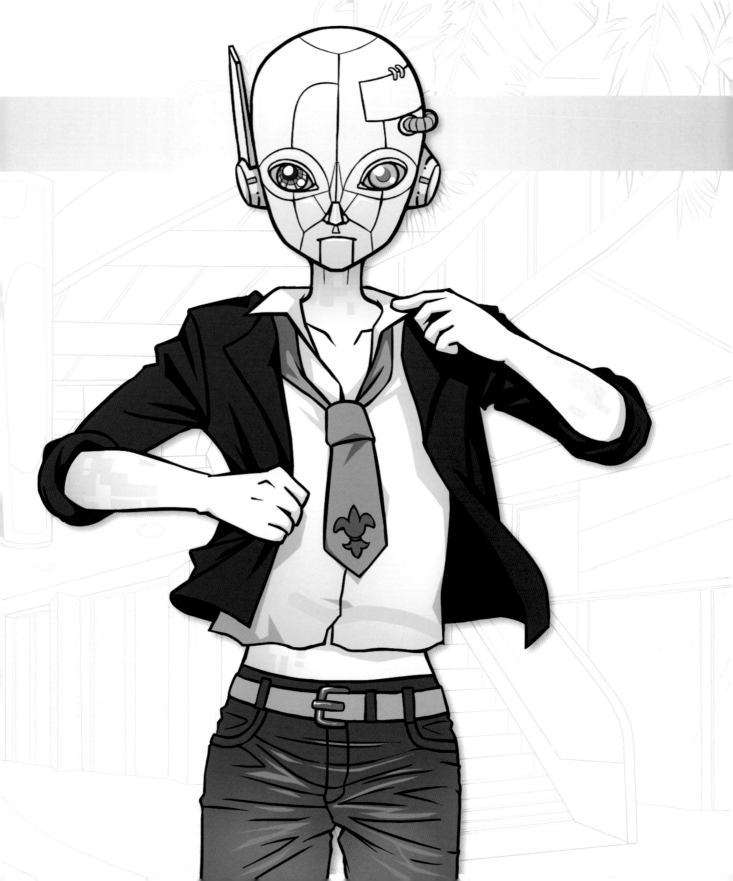

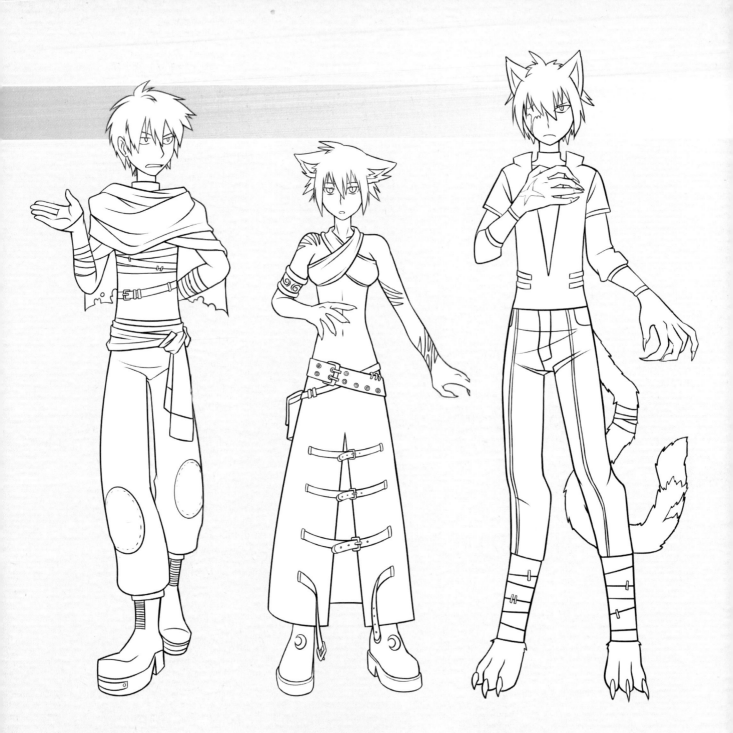

Head: *Male 003*
Upper Body: *Action 005*
Lower Body: *Punk 003*

Head: *Fantasy 006*
Upper Body: *Fantasy 008*
Lower Body: *Goth 010*

Head: *Fantasy 007*
Upper Body: *Fantasy 009*
Lower Body: *Fantasy 009*

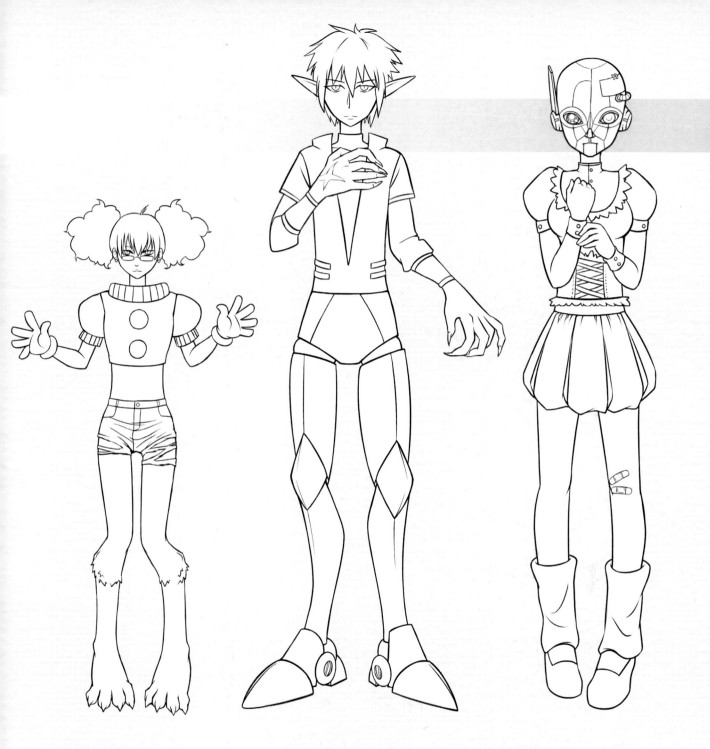

Head: *Female 019*
Upper Body: *Fantasy 002*
Lower Body: *Fantasy 001*

Head: *Fantasy 008*
Upper Body: *Fantasy 009*
Lower Body: *Fantasy 002*

Head: *Fantasy 002*
Upper Body: *Feminine 012*
Lower Body: *Feminine 005*

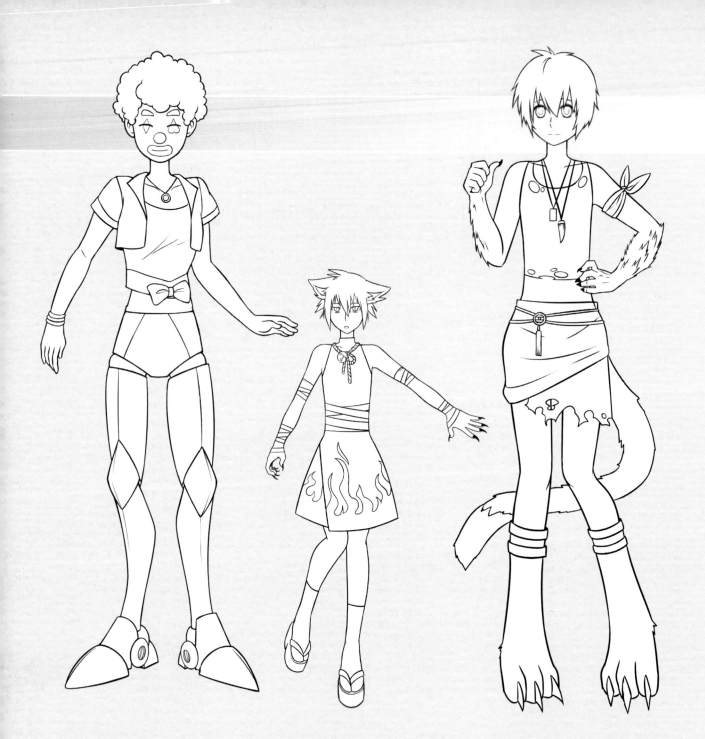

Head: *Fantasy 001*
Upper Body: *Feminine 003*
Lower Body: *Fantasy 002*

Head: *Fantasy 006*
Upper Body: *Fantasy 004*
Lower Body: *Feminine 016*

Head: *Androgynous 011*
Upper Body: *Fantasy 006*
Lower Body: *Fantasy 016*

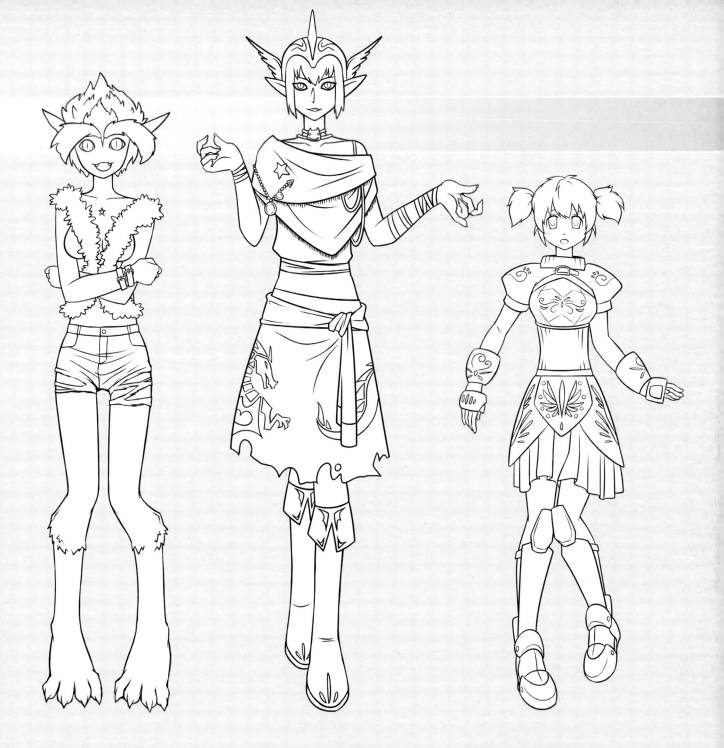

Head: *Fantasy 014*
Upper Body: *Glam 012*
Lower Body: *Fantasy 001*

Head: *Fantasy 012*
Upper Body: *Punk 005*
Lower Body: *Fantasy 003*

Head: *Female 008*
Upper Body: *Fantasy 003*
Lower Body: *Fantasy 007*

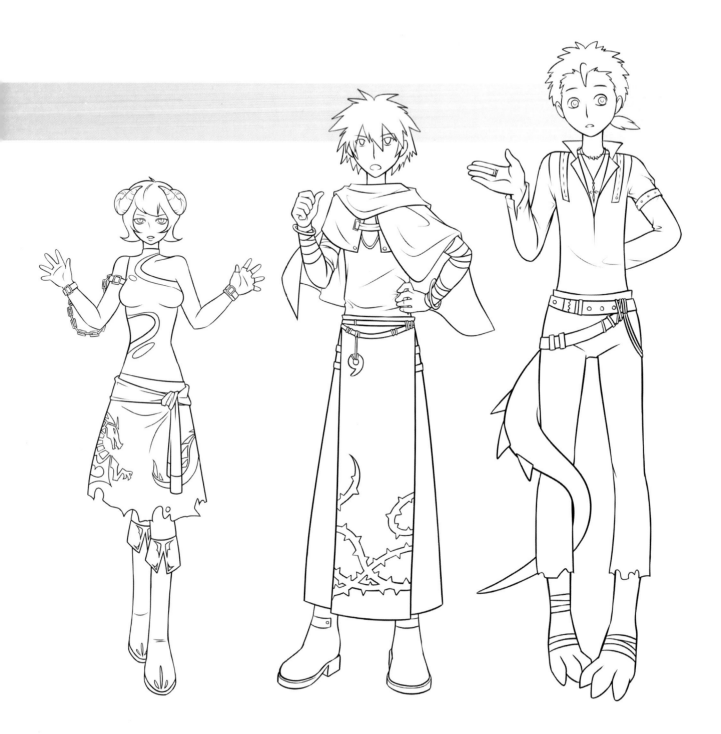

Head: *Fantasy 011*
Upper Body: *Punk 012*
Lower Body: *Fantasy 003*

Head: *Male 021*
Upper Body: *Action 004*
Lower Body: *Fantasy 010*

Head: *Male 009*
Upper Body: *Goth 003*
Lower Body: *Fantasy 015*

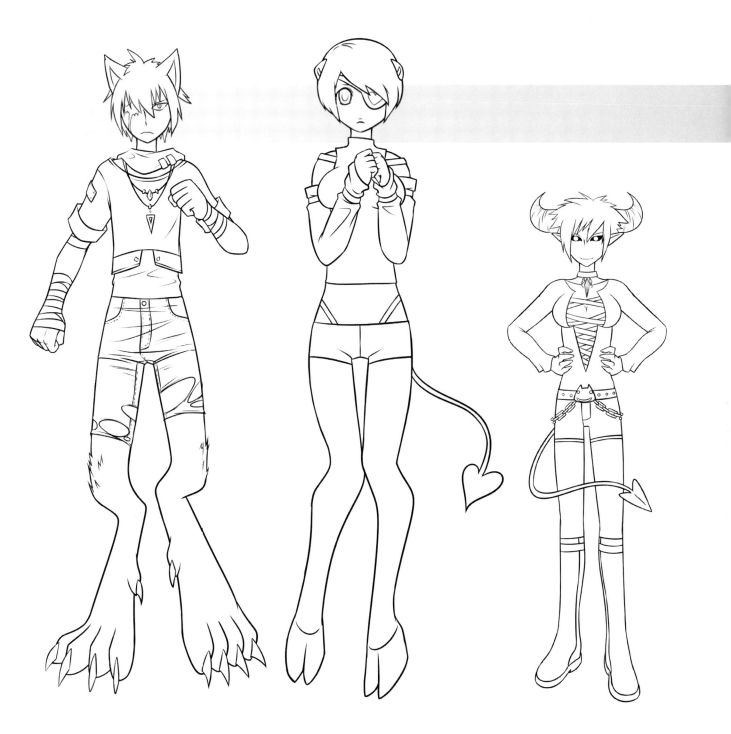

Head: *Fantasy 007*
Upper Body: *Punk 009*
Lower Body: *Fantasy 011*

Head: *Fantasy 003*
Upper Body: *Goth 008*
Lower Body: *Fantasy 013*

Head: *Fantasy 010*
Upper Body: *Glam 002*
Lower Body: *Fantasy 012*

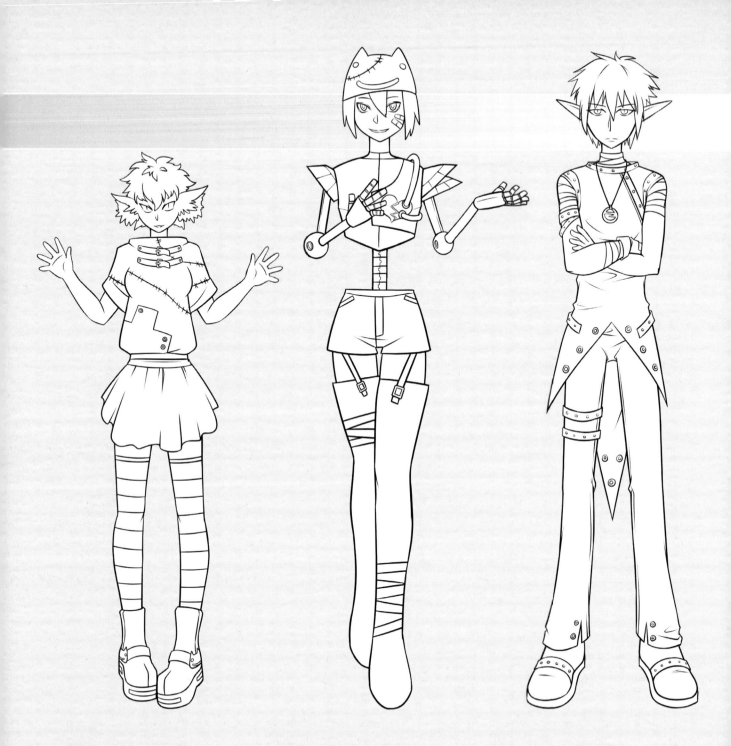

Head: *Fantasy 015*
Upper Body: *Goth 007*
Lower Body: *Punk 005*

Head: *Fantasy 005*
Upper Body: *Fantasy 001*
Lower Body: *Punk 012*

Head: *Fantasy 008*
Upper Body: *Punk 008*
Lower Body: *Glam 005*

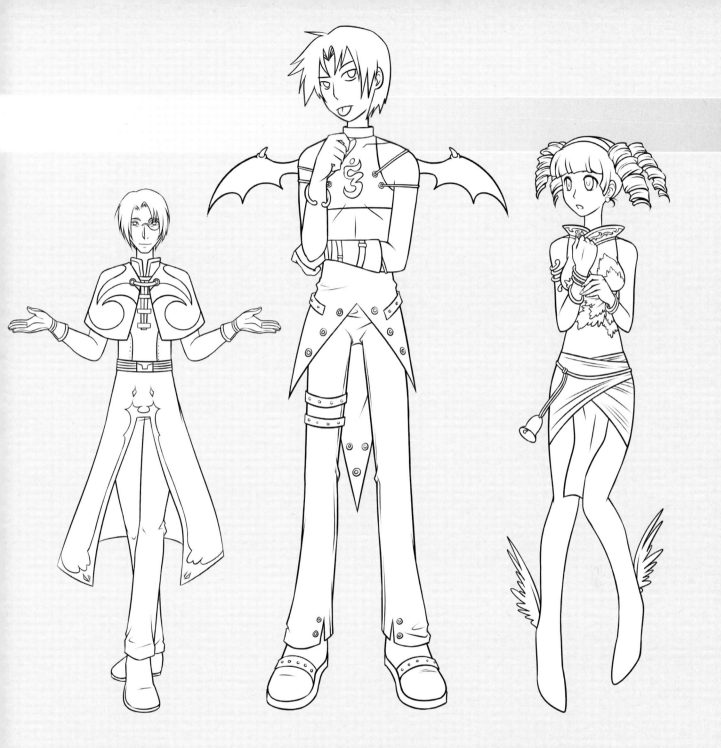

Head: *Male 022*
Upper Body: *Action 006*
Lower Body: *Goth 005*

Head: *Male 020*
Upper Body: *Fantasy 005*
Lower Body: *Glam 005*

Head: *Female 013*
Upper Body: *Glam 011*
Lower Body: *Fantasy 014*

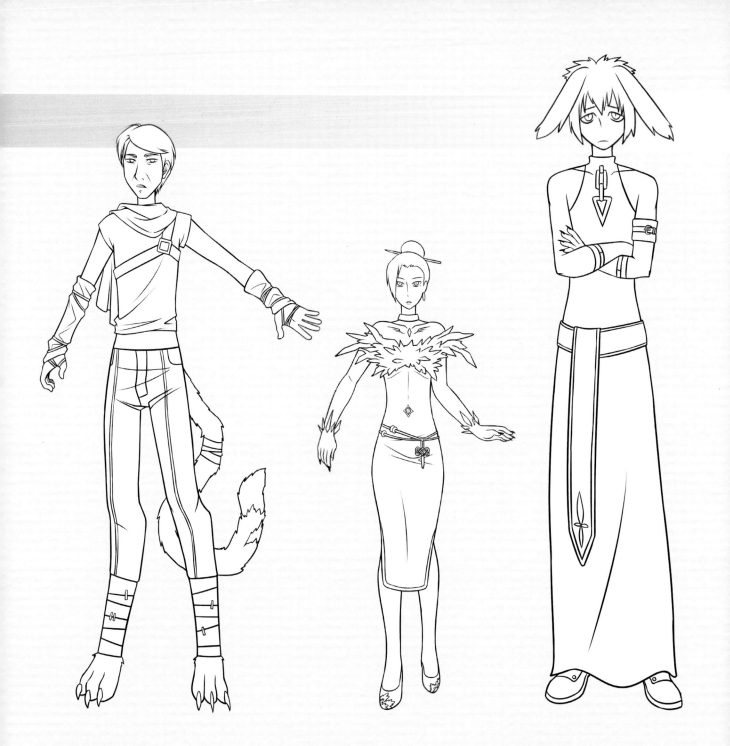

Head: *Male 023*
Upper Body: *Action 003*
Lower Body: *Fantasy 009*

Head: *Female 038*
Upper Body: *Fantasy 007*
Lower Body: *Feminine 015*

Head: *Fantasy 013*
Upper Body: *Goth 009*
Lower Body: *Fantasy 008*

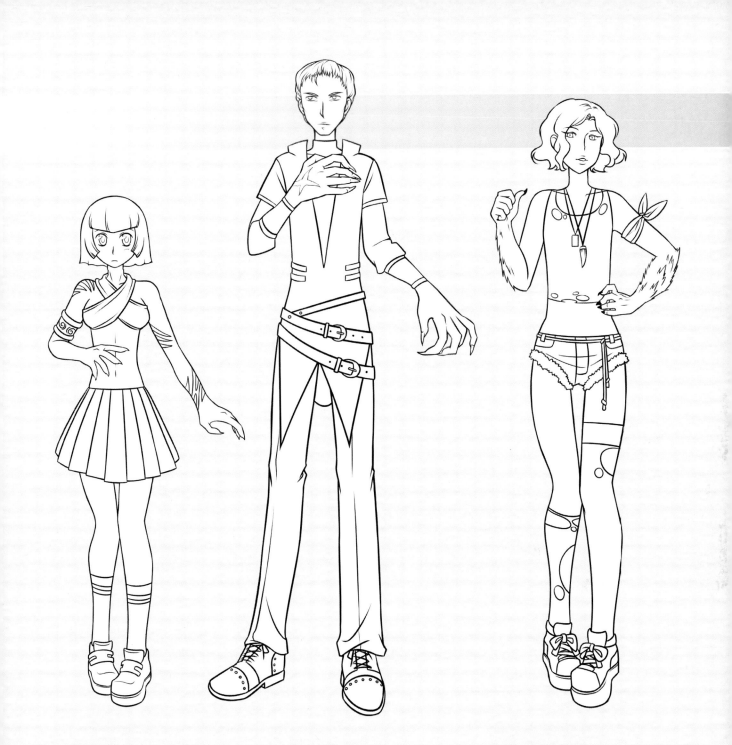

Head: *Female 011*
Upper Body: *Fantasy 008*
Lower Body: *Casual 015*

Head: *Male 024*
Upper Body: *Fantasy 009*
Lower Body: *Punk 013*

Head: *Female 036*
Upper Body: *Fantasy 006*
Lower Body: *Punk 006*

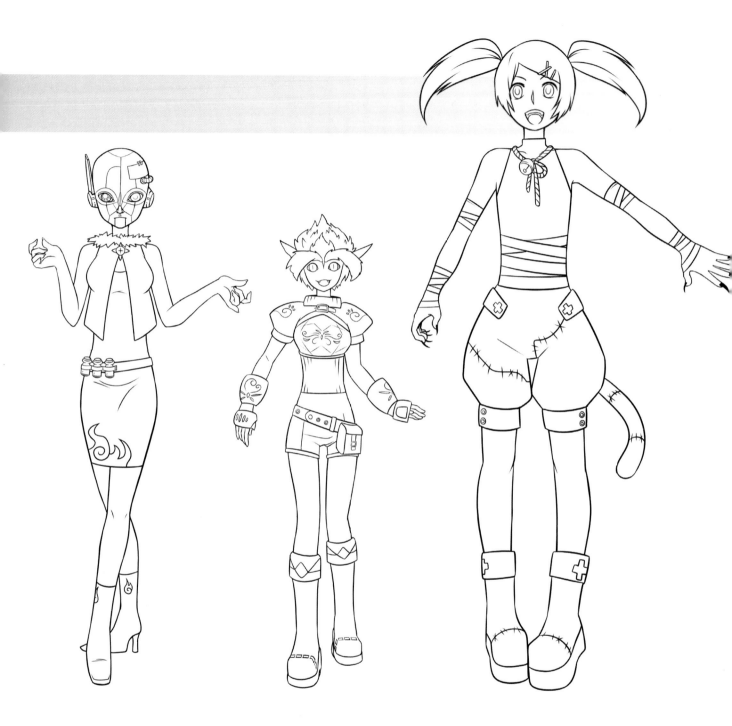

Head: *Fantasy 002*
Upper Body: *Feminine 009*
Lower Body: *Action 015*

Head: *Fantasy 014*
Upper Body: *Fantasy 003*
Lower Body: *Action 009*

Head: *Female 015*
Upper Body: *Fantasy 004*
Lower Body: *Fantasy 006*

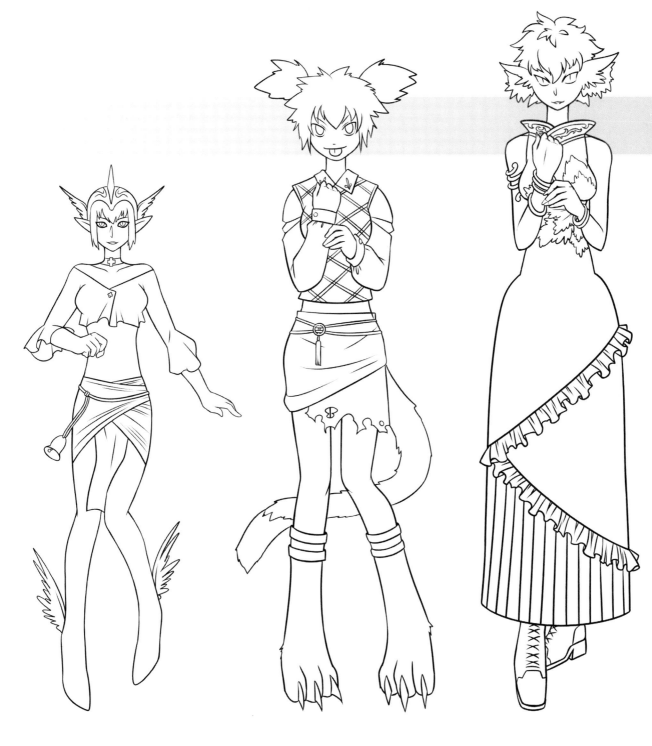

Head: *Fantasy 012*
Upper Body: *Glam 001*
Lower Body: *Fantasy 014*

Head: *Fantasy 004*
Upper Body: *Formal 002*
Lower Body: *Fantasy 016*

Head: *Fantasy 015*
Upper Body: *Glam 011*
Lower Body: *Feminine 014*

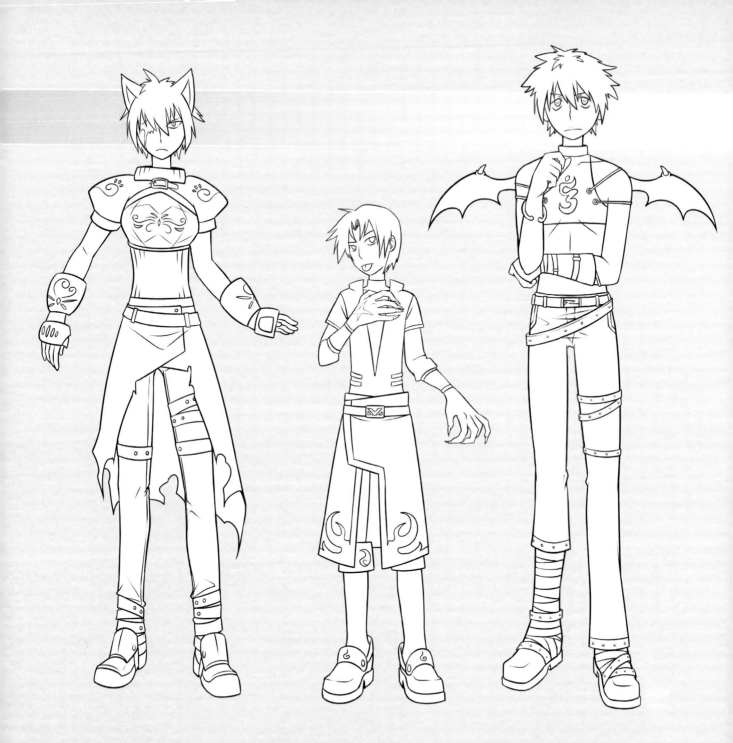

Head: *Fantasy 007*
Upper Body: *Fantasy 003*
Lower Body: *Action 005*

Head: *Male 020*
Upper Body: *Fantasy 009*
Lower Body: *Fantasy 005*

Head: *Male 011*
Upper Body: *Fantasy 005*
Lower Body: *Punk 007*

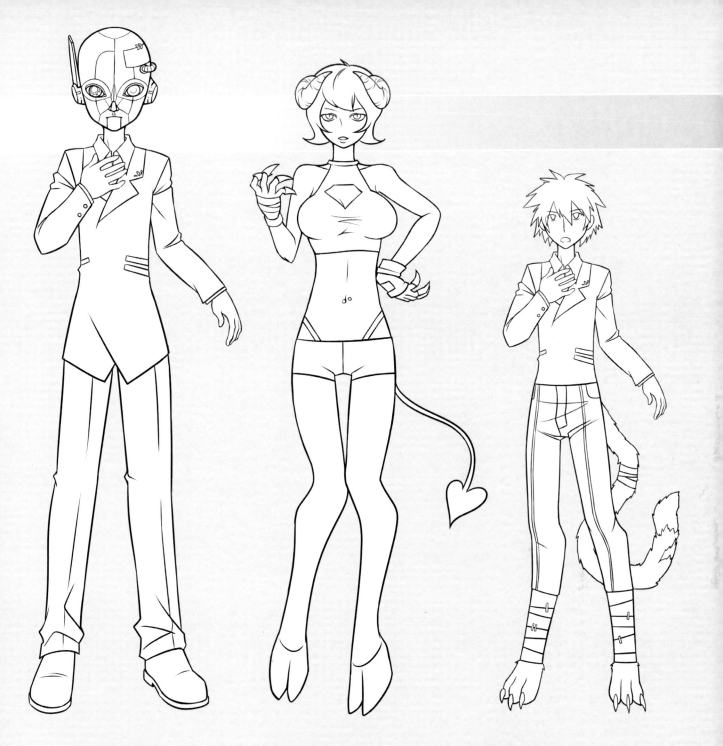

Head: *Fantasy 002*
Upper Body: *Formal 003*
Lower Body: *Work 001*

Head: *Fantasy 011*
Upper Body: *Action 001*
Lower Body: *Fantasy 013*

Head: *Male 021*
Upper Body: *Formal 003*
Lower Body: *Fantasy 009*

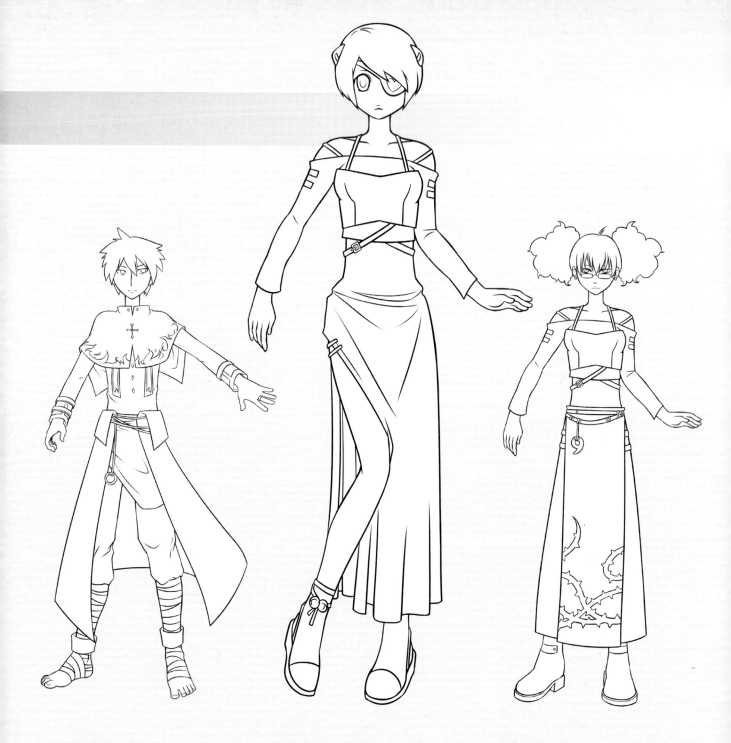

Head: *Male 005*
Upper Body: *Goth 002*
Lower Body: *Action 008*

Head: *Fantasy 003*
Upper Body: *Punk 004*
Lower Body: *Glam 003*

Head: *Female 019*
Upper Body: *Punk 004*
Lower Body: *Fantasy 010*

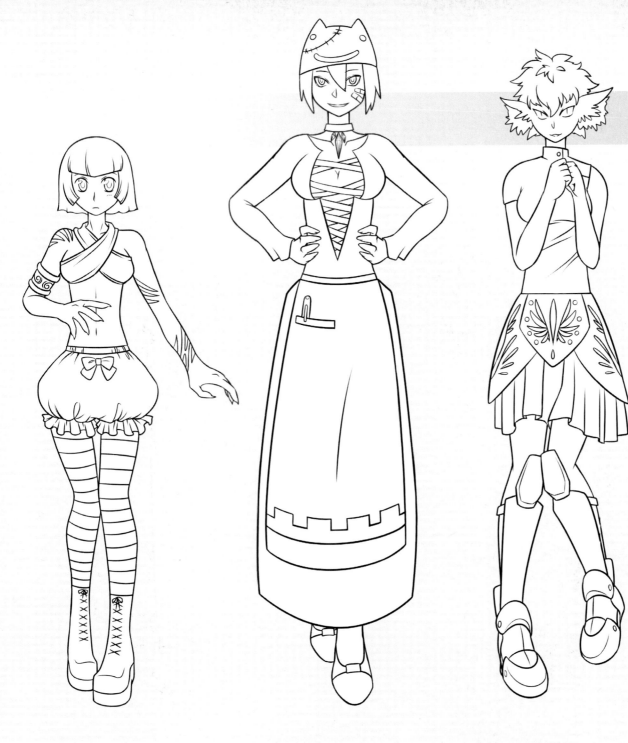

Head: *Female 011*
Upper Body: *Fantasy 008*
Lower Body: *Goth 001*

Head: *Fantasy 005*
Upper Body: *Glam 002*
Lower Body: *Work 003*

Head: *Fantasy 015*
Upper Body: *Feminine 014*
Lower Body: *Fantasy 007*

One Million Manga Characters License Agreement

The One Million Manga Characters image gallery of digitized images ("The Images") on this CD-ROM disc ("The Disc") is licensed for use under the following Terms and Conditions, which define what You may do with the product. Please read them carefully. Use of The Images on The Disc implies that You have read and accepted these terms and conditions in full. If You do not agree to the terms and conditions of this agreement, do not use or copy The Images and return the complete package to The Ilex Press Ltd. with proof of purchase within 15 days for a full refund.

Terms and Conditions of Use

You agree to use The Images under the following Terms and Conditions:

Agreement

1. These Terms and Conditions constitute a legal Agreement between the purchaser ("You" or "Your") and The Ilex Press Ltd. ("Ilex").

2. License

You are granted a non-exclusive, non-transferable license to use, modify, reproduce, publish, and display The Images provided that You comply with the Terms and Conditions of this Agreement.

3. You may, subject to the Terms and Conditions of this Agreement:

a) Use, modify, and enhance The Images (provided that You do not violate the rights of any third party) as a design element in commercial or internal publishing, for advertising or promotional materials, corporate identity, newsletters, video, film, and television broadcasts except as noted in paragraph 4 below.

b) Use, modify, and enhance the images as a design element on a web site, computer game, video game, or multimedia product (but not in connection with any web site template, database, or software product for distribution by others) except as noted in paragraph 4 below.

c) Use one copy of The Disc on a single workstation only.

d) Copy the images to Your hard drive.

e) Make a temporary copy of The Images, if You intend to output the images using a device owned or operated by a third party, such as a service bureau image setter. Such copies must be destroyed at the end of the production cycle.

4. You may not:

a) Distribute, copy, transfer, assign, rent, lease, resell, give away, or barter the images, electronically or in hard copy, except as expressly permitted under paragraph 3 above.

b) Distribute or incorporate the images into another photo or image library or any similar product, or otherwise make available The Images for use or distribution separately or detached from a product or web page, either by copying or electronically downloading in any form.

c) Use the The Images to represent any living person.

d) Modify and use The Images in connection with pornographic, libelous, obscene, immoral, defamatory, or otherwise illegal material.

e) Use The Images as part of any trademark whether registered or not.

f) Transfer possession of The Images to another person across a network, on a CD, or by any other method now known or hereafter invented.

5. Termination

This license is in force until terminated. If You do not comply with the terms and conditions above, the license automatically terminates. At termination, the product must be destroyed or returned to Ilex.

6. Warranties

a) Ilex warrants that the media on which The Images are supplied will be free from defects in material and workmanship under normal use for 90 days. Any media found to be defective will be replaced free of charge by returning the media to our offices with a copy of Your receipt. If Ilex cannot replace the media, it will refund the full purchase price.

b) The Images are provided "as is," "as available," and "with all faults," without warranty of any kind, either expressed or implied, including but not limited to the implied warranties or merchantability and fitness for a particular purpose. The entire risk as to quality, accuracy, and performance of The Images is with You. In no event will Ilex, its employees, directors, officers, or its agents or dealers or anyone else associated with Ilex be liable to You for any damages, including any lost profit, lost savings, or any other consequential damages arising from the use of or inability to use The Images even if Ilex, its employees, directors, officers, or its agent or authorized dealer or anyone else associated with Ilex has been advised of the possibility of such damages or for any claim by any other party. Our maximum liability to You shall not exceed the amount paid for the product.

c) You warrant You do not reside in any country to which export of USA products is prohibited or restricted or that Your use of The Images will not violate any applicable law or regulation of any country, state, or other governmental entity.

d) You warrant that You will not use The Images in any way that is not permitted by this Agreement.

7. General

a) The Disc, The Images, and its accompanying documentation is copyrighted. You may digitally manipulate, add other graphic elements to, or otherwise modify The Images in full realization that they remain copyrighted in such modification.

b) The Images are protected by the United States Copyright laws, international treaty provisions and other applicable laws. No title to or intellectual property rights to The Images or The Disc are transferred to You.

c) You acknowledge that You have read this agreement, understand it, and agree to be bound by its terms and conditions. You agree that it supersedes any proposal or prior agreement, oral or written, and that it may not be changed except by a signed written agreement.